THE SERPENT MOUND
ADAMS COUNTY, OHIO.

MYSTERY OF THE MOUND AND HISTORY OF THE SERPENT.

VARIOUS THEORIES OF THE EFFIGY MOUNDS AND THE MOUND BUILDERS.

BY

E. O. RANDALL, LL. M.,

Secretary Ohio State Archæological and Historical Society;
Reporter Ohio Supreme Court.

COACHWHIP PUBLICATIONS
Greenville, Ohio

The Serpent Mound, by E. O. Randall
© 2013 Coachwhip Publications
First published 1905.
All rights reserved.
No claims made on public domain material.

ISBN 1-61646-167-5
ISBN-13 978-1-61646-167-6

CoachwhipBooks.com

(3)

PREFATORY NOTE.

The monograph herewith produced concerning the Serpent Mound was prepared — we use the word "prepared" as it will be evident to the reader that it has been largely written by other authorities — at the request of the Trustees of the Ohio State Archaeological and Historical Society in the attempt to meet the demand of the hundreds of visitors from every section of the country, indeed from all parts of the world, to the Serpent Mound. The effort has been made not merely to give a description, indeed several descriptions, of Serpent Mound, but also to set forth a summary of the literature concerning the worship of the serpent. In this latter subject copious excerpts from the leading authorities have been given because the books upon that subject are rare and mostly inaccessible to the general reader. It is hoped that this little volume, while it may not solve the problem of the origin and purpose of the Serpent Mound, will at least add to its interest and give the reader such information as it is possible to obtain. E. O. R.

Columbus, October, 1905.

SERPENT MOUND.

Among all the monuments, curious, vast and inexplicable left by the Mound Builders the Serpent Mound is the most mysterious and awe-inspiring. It is located in Bratton Township, northern part of Adams County. The country there presents a region of hill, dale, plain and stream of harmonious variety and most pleasing beauty. In the upper part of this county there rises a picturesque and meandering little river known as Brush Creek. This creek is created by the confluence of tributary streams, the chief ones being called the East Fork, the Middle Fork and the West Fork; the East and West Forks, flowing from the directions indicated in their names, unite a short distance north of the mound; the Middle Fork originates in.Highland County and flowing south empties into the East Fork just above its juncture with the West Fork; the meeting of these three prongs of the river fork that forms Brush Creek can be easily seen from the Mound Bluff. Along the east side of Brush Creek, which flows directly south into the Ohio, beginning almost imperceptibly a mile or

more below the East and West Fork junction and running parallel with the creek is a hilly elevation of land, the summit of which forms a long stretch of plateau. This table plain, its sloping sides rising higher and higher, suddenly terminates at its northern end in a sharp, jutting bluff with an almost per-

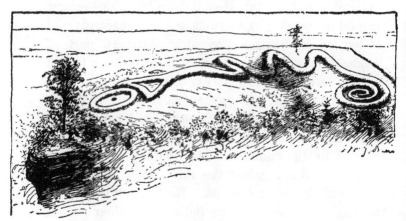

THE GREAT SERPENT.

pendicular cliff wall, averaging a hundred feet high on the west, where it overhangs Brush Creek, whose waters wash its base. This bluff surmounts on the north and for a slight distance on the east, a steep, deep ravine, forming the bed of a rivulet which for want of a definite name we designate Small Run. The north and east banks of Small Run recede gradually

to a height much lower than the elevated peak just described, so that the narrow neck or ridge spur, thus carved out of the hill side, towers boldly and abruptly, in full view, from the deep level below. The bluff is crowned with immense protruding rocks that like a brow of rugged furrows frown defiantly at the pretty hills, peacefully skirting the horizon far beyond the intervening plain. Upon the crest of this high ridge lies in graceful and gigantic undulations the Great Serpent. The high summit upon which the serpent appears to wind his way, is crescent shaped, its concave side being on the west, against the Brush Creek valley; this table top is moreover highest at its southeastern section, where it starts from the plateau or broad hill summit, whence it pitches gently downward to its western edge and its projecting north end. This tipped surface enabled his creators and promoters to so place the wonderful serpent upon a shelving bed that he would easily be seen in all his majestic length and snake splendor from far and near on the plains below. For exhibition purposes no finer opportunity from a natural combination of features, could have been found in the Ohio valley and perhaps not in the Mississippi basin. Here was a superb inclined stage, elevated before a spacious hill-surrounded pit, miles in circumference and afford-

ing ample accommodations for audiences of untold numbers. The serpent, beginning with his tip end, starts in a triple coil of the tail on the most marked elevation of the ridge and extends along down the lowering crest in beautiful folds, curving gracefully to right and left and swerving deftly over a depression in the center of his path and winding in easy and natural convolutions down the narrowing ledge with head and neck stretched out serpent-like and pointed to the west; the head is apparently turned upon its right side with the great mouth wide open, the extremities of the jaws, the upper or northern lying one being the longer, united by a concave bank immediately in front of which is a large oval or egg-shaped hollow eighty-six feet long and and thirty feet wide at its greatest inside transverse, formed by the artificial embankment from two to three feet high and about twenty feet wide at its base. The oval is therefore one hundred and twenty feet long, outside measurement, and sixty feet in its greatest width. The head of the serpent across the point of union of the jaws is thirty feet wide, the jaws and connecting crescent five feet high. The entire length of the serpent, following the convolutions, is thirteen hundred and thirty-five feet. Its width at the largest portion of the body is twenty feet. At the tail the width is

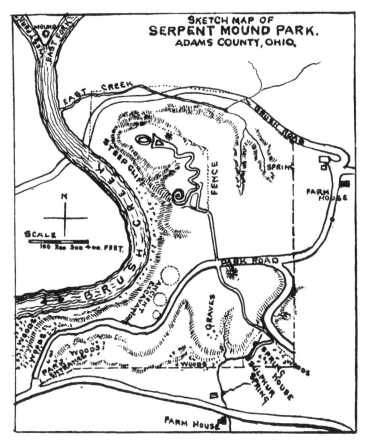

VICINITY OF THE SERPENT MOUND.

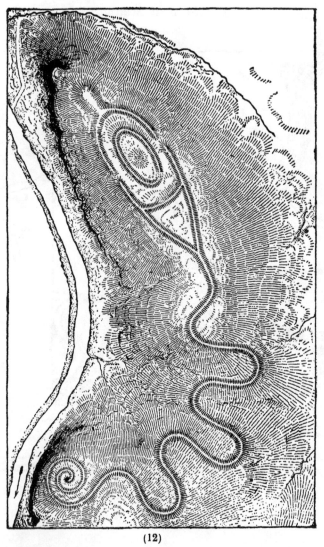

HOLME'S FIGURE OF THE SERPENT MOUND.

no more than four or five feet. Here the height is
from three to four feet, which increases towards the
center of the body to a height of five to six feet. The
air line distance from the north side oval and head to
the southern coil of the tail is about five hundred feet.
The total length of the entire work, if extended in full
length, from west end of the oval to the tip of the
tail, is fourteen hundred and fifteen feet. Such is the
size of the enormous earthen reptile as it has lain,
basking in the suns or shivering in the snows of many
centuries. The effect the sight of it produces, from
close inspection or distant view, can scarcely be imag-
ined or described. Prof. F. W. Putnam of the Pea-
body Museum and to whom is due the credit of the
restoration and preservation of the mound, says in
the account of his first visit: "The graceful curves
throughout the whole length of this singular effigy
give it a strange life-like appearance; as if a huge
serpent, slowly uncoiling itself and creeping silently
and stealthily along the crest of the hill, was about to
seize the oval within its extended jaws. Late in the
afternoon, when the lights and shades are brought
out in strong relief, the effect is indeed strange and
weird; and this effect is heightened still more when
the full moon lights up the scene and the stillness is
broken by the 'whoo-whoo, hoo-hoo' of the unseen bird

of night. Reclining on one of the huge folds of this gigantic serpent, as the last rays of the sun gleaming from the distant hilltops, cast their long shadows over the valley, I mused on the probabilities of the past; and there seemed to come to me a picture as of a distant time, of a people with strange customs, and with it came the demand for an interpretation of this mystery. The unknown must become known."

Prof. W. H. Holmes, of the Smithsonian Institution, was equally impressed with the mystery of this curious creature of singular art. Mr. Holmes states: "The topography of the outer end of this promontory is somewhat peculiar. The extreme point is about thirty feet beyond the end of the artificial embankment, and is slightly cleft in the middle. The right hand portion has no exposure of rock and descends in a narrow rounded spur. The left hand is a naked shelf of rock a little to the left of the direct continuation of the earth work, and some ten feet below its terminal point. It is rounded at the margin and perhaps twenty-five feet wide. The vertical outline is curved and presents a number of connecting ledges marking the thickness of the finer strata. The entire exposure of rock at this point is perhaps forty feet in height. Beneath this a talus (supporting slope) extends to the creek bottom. From this point,

the exposure of rock extends back along down the creek, descending slightly and soon disappearing. From the bank of the creek one has a comprehensive view of the serpent ridge. Having the idea of a great serpent in mind, one is struck with the remarkable contour of the bluff, and especially of the exposure of the rock, which readily assumes the appearance of the reptile lifting its front from the bed of the stream. The head is the point of the rock, the dark, lip-like edge is the muzzle, the light colored under side is the white neck, the caves are the eyes, and the projecting masses to the right are the protruding coils of the body. The varying effects of light must greatly increase the vividness of the impression and nothing would be more natural than that the Sylvan prophet should at once regard the promontory as a great Manito, (or spiritual being.) His people could be led to regard it as such, and this would result in the elaboration of the forms of the reptile, that it might be more real. The natural and the artificial features must all have been related to one and the same conception. The point of naked rock was probably at first and always recognized as the head of both the natural and artificial body. It was to the Indian the real head of the great serpent Manito."

Concerning the curious construction of the face of the cliff upon which the Serpent Mound is erected, Prof. Josua Lindahl, Secretary and Curator of the Cincinnati Society of Natural History, has an interesting theory, which he put forth a year or two ago in a public address based upon his own observations of the Serpent Mound. Dr. Lindahl says:

"The Construction of this work by some early human race was preceded, by some thousand of years, by the sculpturing of the precipice, by natural agencies, into a grotesque face. Prof. Holmes describes this face as reptilian; to me it appeared more reminding of a human face. At all events, it is a face of so striking appearance, that it must necessarily have aroused the wonder of the aborigines when they first came there — and that face must have first suggested to those people the idea of building the mound.

"The face was made by the same forces which excavated, at the close of the glacial period, the river valley on one side, and the ravine on the other side of the rock spur, on the top of which, in much later time, the mound was built. The strata of rock vary greatly in hardness, from compact limestone and soft shale to clay which will be easily washed away by rain where exposed. A little below the top is a stratum very much harder than those nearest above and below and,

having resisted atmospheric action better than the others, it projects beyond them. This stratum forms the *nose* of the face. A few feet lower down is the *chin,* still harder than any of the other strata, hence projecting much more. Between this "chin" and the "nose" are a few feet of mostly moderately hard limestone, but among them is a thin layer (an inch or two) of clay which is always washed out near the surface, leaving an opening at the extreme edge of the rock, suggesting a *mouth.* Below the "chin" all strata are soft and have been considerably eroded. The face is formed from the ten to fifteen uppermost strata of the one hundred feet high spur. The "nose" consists of a stratum containing many big and small nodules, one of which forms a bump on the nose. Some of these nodules have dropped out, leaving empty gills. I saw one such pit (oval) big enough to make room for a watermelon at the other side, facing Brush Creek.

"What would be more natural for ignorant savages than to think that this face was carved by the Great Spirit, their Great Manitou, as a warning to them that the spot was sacred? And what would then be more natural than that these people should use that spur of land for sacred rites and adorn it appropriately. There was the face. On the top of it they put an oval, the skull, now almost effaced, and

back of this the body and tail of the reptile which to
them was a symbol of the Great Manitou. That *skull*
I saw plainly. It is not raised like the parts restored
by Putnam; but the grass has a different shade of
green (indicating a different soil) on a spot with a
sharply defined outline and perfectly symmetrical
form, extending from near the edge of the precipice,
where the soil has been washed away, and continued
backward by two symmetrical curves, corresponding
to the curves of the so-called "jaw" of the snake, to
which they, no doubt, were joined originally."

CONSTRUCTION OF THE SERPENT MOUND.

The most scientific and satisfactory examination
of the structure of this serpent was made by Prof.
Putnam, who carefully excavated sections of the ser-
pent and made explorations in the adjacent ground
and the nearby mounds. We quote from the inter-
esting report of the professor:

"This portion of the hill was either leveled off to
the clay before the oval work was made, or there was
no black soil upon the hill at that time, as none was
used in the construction of the embankment, nor left
below it. The same is true of the serpent itself.
Careful examination of several sections made through
the oval and the serpent, as well as laying bare the

edge along both sides of the embankments throughout, have shown that both parts of this earthwork were both outlined upon a smooth surface along the ridge

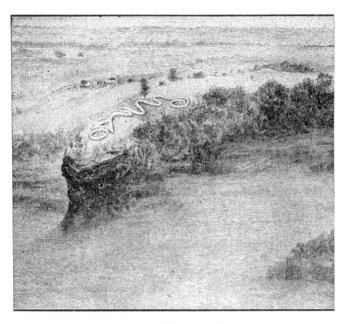

SERPENT MOUND AND CLIFF.

of the hill. In some places, particularly at the western end of the oval, and where the serpent approached the steeper portions of the hill, the base was made with stones, as if to prevent it being washed away by

heavy rains. In other places clay, often mixed with
ashes, was used in making these outlines; and it is
evident that the whole structure was most carefully
planned, and thoroughly built of lasting material.
The geological formation of the hill shows first the
ledge rock, upon which rests the decayed grayish rock
forming the so-called marl of the region, the upper
portion of which has by decomposition become a gray-
ish clay. Over this lies the yellow clay of the region,
filling in all irregularities, and varying in thickness
from one to six feet. Upon this rests the dark soil of
recent formation, from five inches to nearly two feet
in thickness in different parts of the park. It is nec-
essary to have this formation constantly in mind, as
we must, to a certain extent, rely upon it in determin-
ing the antiquity of the works and burial-places.
Upon removing the sod within the oval the dark soil in
the central portion was found to be nearly a foot
in depth, where it must have formed after the oval
work was built. How many centuries are required
for the formation of a foot of vegetable mold we do
not know; but here on the hard gray clay forming the
floor of the oval, was about the same depth of soil as
on the level ground near the tail of the serpent,
where it has been forming ever since vegetation began
to grow upon the spot. The same results were ob-

tained on removing the soil from the triangular space between the serpent's jaws; and that there was about the same amount of soil on the embankment is shown by the fact that the several plowings had not disturbed the underlying clay of which the embankments were constructed. The accompanying section through the western end of the oval illustrates this point."

PROF. PUTNAM'S EXPLORATIONS.

The investigations of Professors Putnam, Holmes, Moorehead and others prove conclusively that the plateau immediately south of the serpent was the dwelling place of the prehistoric man. Burials, burnt places, ash beds and similar evidences marked the sites of cemeteries or villages. In the graves about the unearthed hearths, or here and there in the ground, were found thousands of chips and flakes of flint, rough pieces of jasper, quartz and other rocks; burnished implements; chisel-shaped and sharp-edged knives, spear points, arrow heads; chipped drills and perforators; ornaments and implements made of bones of animals and birds; pieces of rude pottery and fragments of cooking and other utensils; bones of fish, turtles, birds and remains of various animals used for food. All these articles showed beyond

question there had here been settlements of the ancient people. There was evidence of dwellings and burials of different times. Two or three small mounds were found near the head of the serpent. On the plateau level just south of the serpent were ample evidences of very ancient habitations and burials. There were here several small mounds and one, the most conspicuous of all, just south of the park road, was a conical-shaped mound nine feet high and seventy feet in diameter. This is the mound upon which the granite monument now stands. This mound was opened and found to have been erected undoubtedly as the monument to some important man, buried amid the unusual ceremonies and form of interment. As this was the most interesting and important burial discovered in the vicinity of the serpent and is typical of the many unusual interments of the Mound Builders, we give in full the report of the exhumation by Professor Putnam: "First an area seventy by seventy-one feet in diameter was cleared of all the dark soil, and the clay was also removed for several inches in depth, making a clear level floor. Eleven feet northwest of the center a trench was dug, 14 inches deep, 2 feet wide, and 5 feet long, and filled with loose clay, in which were a few small stones and several broken bones of animals. On the south side from 6

to 11 feet from the center and from 1 to 5 feet apart were four small holes in the clay and 14 inches southeast of the center was another. Each contained stones or a few animal bones or ashes. On the north side from 2 to 6 feet from the center were four more of these holes in which were small stones and animal bones. These holes varied from a few inches to over a foot in depth and from 2 feet to nearly 7 feet in

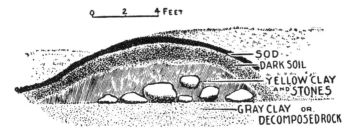

TRANSVERSE SECTIONS OF THE GREAT SERPENT.

diameter. Their position and the fact that they each contained something intentionally placed in them shows they were made for a purpose. It was evident from their character that they were not places where posts had stood forming a part of a wooden structure. Over this cleared area and of course covering all these holes and the trench, clay was placed, forming a level platform 18-inches high. In the central portion of this platform, covering a space 30 by

35 feet in diameter, a fire had been kindled and kept burning until a bed of ashes a few inches in thickness was made, to which may have been added ashes brought from other places, perhaps in great part from the burnt area extending for nearly 100 feet north of the mound. In this ash bed were found many small bits of pottery, pieces of burnt bone and many stone chips; several broken stone implements and about a dozen perfect ones; also pieces of the shells of fresh water clams; all of which is suggestive of scraping up ashes from various hearths and depositing all upon the heap. That a large part of the ashes were made on the spot was evident from the burnt clay below and from the several continuous masses of charcoal, the remains of logs from 2 to 4 inches in diameter. When this ceremony was finished and enough ashes for the desired purpose had been obtained the body of an adult man, nearly 6 feet tall, was placed, with the head to the east, at full length upon the hot ashes, and at once covered with clay, smothering the still smoldering logs and changing the embers to charcoal. Objects of a lasting nature do not seem to have been placed with the body unless some of the chipped flint points found near it in the ashes may be so considered. It may be asked if this was not an unsuccessful case of cremation;

but I think that question may be answered in the negative; for while cremation was often practiced as I have found on other occasions, it was by different methods, and the ashes and calcined bones were afterwards gathered up for burial, or buried in a peculiar manner of the place of burning. This skeleton was that of a well-developed man of ordinary size. The skull was crushed by the weight of the earth above. After the immediate covering of the body with clay, the mound was raised, a symmetrical conical heap of clay to the height of 10 or 12 feet. Some time subsequent to the building of the mound and after the clay had settled into a compact mass, graves were dug upon its sides and top and nine burials had taken place. Some of the intrusive graves were so near the surface that in plowing over the mound the bones had been disturbed, while others were much deeper. One skeleton was found on the eastern side of the mound and four feet from the exterior at a greater depth from the top of the mound another skeleton was found. These skeletons were extended in different directions. Woodchucks had made their burrows in one part of the mound and had thrown out portions of a skull and other parts of a skeleton among the bones of which the woodchucks had made their nest. The bones in most of these graves, especially when

near the surface of the mound, were much decayed
and only fragments of the skeleton could be traced.
In one instance only was anything found with the
skeleton, and that was a fine stone hatchet resting
with its edge outward on the bones of the left fore-
arm, as if the handle had been placed along the arm
and held in the hand. In the exploration of this
mound many stone implements were found, princi-
pally near the bottom on a level with the ash bed.
Among the objects of special interest found in or near
the ash bed of the first burial were a hemisphere of
hematite, a plummet-shaped instrument, a small
hatchet, and several perfect points chipped from
flint, also two finely finished and polished stone axes,
with straight backs and grooves around them for hold-
ing the ribs by which they were fastened, to handles.
There was also found near the edge of the ashes of
this burial a plate of copper $9\frac{1}{2}$ inches long and $3\frac{1}{2}$
inches wide and $\frac{1}{8}$ to nearly $\frac{1}{4}$ of an inch thick, un-
questionably hammered out of native copper."

Several hundred feet southwest of the monument
mound was a small mound which upon exploration
was found to contain, according to Professor Putnam,
the first burials which had an antiquity as great as
that of the serpent itself and "we have every reason
to believe that the bodies buried at this spot were of

the people who worshiped at the serpent shrine."
Professor Putnam thus describes the contents of this
mound: "On the clay of the knoll a number of large
stones had been placed and over these had been raised
a small mound, oblong in shape, and probably not
over two or three feet high. In leveling the mound
and plowing over the spot many of these stones had
been turned out and thrown down the hill; but a few
still remained near which we started a preliminary
trench. About a foot below the natural surface of
the clay we found other stones, irregularly placed
over an area about 7 feet long east and west and 4
feet wide north and south, resting upon a bed of ashes
nearly a foot thick; and under this ash bed were three
more irregular groups which proved to be graves, one
under the eastern corner of the ash bed, one under
the southeastern, and one under the northwestern
portion. In each of these graves were the remains of
human skeletons, lying in the clay and covered with
ashes containing considerable charcoal; and here
again below these graves, were half a dozen boulders,
from one to two feet in diameter, and around them
the edges of other stones, some of which were rounded
boulders and others pieces of ledge rock about 4 inches
thick and a foot or two long, which marked another
grave 7 feet long and 2 feet wide. Here, too, were

found the remains of a skeleton, resting upon flat
stones. This grave, of course, contained the first
burial of the four that had taken place at this spot,
and was made two feet below the bottom of the upper-
most layer of stone covering all the graves. The great
weight from above had crushed the skull and other
portions of the skeleton, and the fragments were
firmly imbedded in the hard, yellow clay which had
silted into the grave, mixed with ashes which had been
thrown over the body. This mass had become so hard
and compact that it seemed more like taking fossils
from a plain rock than human bones from a grave.
The clay immediately under the bottom stone was
filled with bog iron, which had been deposited by
water percolating among the stone, and the iron had
also penetrated the bones. Several rude flint imple-
ments and flint flakes were found in the grave. The
fragments of bone in all the graves show that all
four skeletons were those of fully grown persons and
probably all men. With the knowledge obtained
from the exploration of thousand of graves, under
many and varied conditions of burial, in various parts
of the country, during nearly a quarter of a century of
active field work, I am able to state that all the con-
ditions relating to these graves are confirmatory of

their great antiquity; indeed, I have seldom found more conclusive comparative evidence of antiquity of graves than in those now under consideration."

Professor Putnam, corroborated by other scholarly and trustworthy authorities, establishes the great age of these burials and deep sunken hearth sites or fire places by their relative placement in the strata of the various clays and the subsequent coverings of other soils and vegetation deposits and layers, the formation of which must have been nature, the slow work of nature requiring centuries of time to thus cast its coverings over the artificial work of ancient man.

That the Mound Builders' works are very ancient is proven in many ways. By the testimony of the primitive articles and implements found in the mounds and graves; by the testimony of the creeks and rivers in the changes of their courses since the mounds were built and by the great trees that have grown upon these mounds, some of them being six hundred years old and probably second or third growths, scholars conclude these great works are at least hundreds of years old and perhaps many thousands. It is plausibly guessed that these people belonged to the Stone Age, for their implements are

almost entirely of that material. They had not
learned the value and use of iron or other metal
articles.

The antiquity of the Mound Builder is further
determined by the objects unearthed and the evi-
dent result upon them of chemical and geological
forces of nature. Professor Putnam, in the *Cen-
tury Magazine* for April 1890, from which we
have copiously quoted, has described with great
clearness and detail the result of his investigations
at Serpent Mound. His careful, scientific and un-
imaginative conclusions seem to clearly demonstrate
that the Serpent Mound was the work of most ancient
people, populous, energetic, prompted by religious
motives and given to ceremonies of great exactness
and elaboration. But still the real purpose of the
serpent is no nearer solution than before; "the un-
known must become known," the Professor exclaimed.
But the knowledge still lies buried, deeper than any
prehistoric man, in the very depths of the unknown.
The great serpent still holds within his coils the secret
of his existence as silent and impenetrable as the mid-
night hush of his solitary abode on the mountain side
far above the plains and valleys. It is most interest-
ing and indeed in many respects informing, if not alto-
gether satisfactory, and certainly not conclusive, to

consider the theories concerning the purpose and significance of the Great Serpent Mound. It is unquestionably to be classed with what are known as

EFFIGY MOUNDS.

The subject of effigy mounds presents a separate, distinct and unique study for the archaeologist. The effigy mounds appear more or less numerously in various parts of the mound-building country, the Mississippi valley. They are found in many of the southern states; many appear in Illinois, but Wisconsin seems to have been their peculiar field. Hundreds of them were discovered in that state and were examined and described in official reports for the Smithsonian Institute. In Wisconsin they represent innumerable animal forms; the moose, buffalo, bear, fox, deer, frog, eagle, hawk, panther, elephant, and various fishes, birds and even men and women. In a few instances, a snake. In Wisconsin the effigies were usually situated on high ridges along the rivers or on the elevated shores of the lake. Very few effigy mounds have been found in Ohio — though it is by far the richest field in other forms of mounds.

The most notable Ohio effigies, if indeed not the only ones, are the so-called Eagle Mound at Newark, the Alligator or Opossum Mound at Granville and

the Great Serpent Mound in Adams County. This
latter is the largest and one of the most distinctly de-
fined effigy mounds in the United States and perhaps
in the world. The purpose and significance of these
effigy mounds have thus far baffled explanation. This
theme can only be treated by anology. As we learn
from the publications of Dr. Stephen D Peet, editor
of the *American Antiquarian,* one of the chief theories
is, that these animal mounds were emblematic of vari-
ous tribes or families of the Mound Builders, as the
totem among the Indians was the token or symbol of
a family or clan. This totem was usually an animal
or natural object selected for reverence and super-
stitious regard. It also among the Indians served
as a sort of surname of the family. The turtle, the
bear and the wolf were, for example, favored and hon-
ored totems. Even among modern civilized nations
this idea is perpetuated, with less significance, of
course, as the adoption by popular use of the Eagle as
the emblem of the United States, the Lion by Eng-
land, the Bear by Russia, etc. With the Indians this
emblem or totem would be represented often in crude
wooden images. Adopting this idea, it has been held
that the effigy mounds represented the animal em-
blems or totems of racial divisions and that perhaps
these mounds were erected either at the village site of

the family it represented or possibly the burial place, it being in the latter case a sort of representative monument to designate the family or tribe the members of which were buried about or in the vicinity of the monument totem.

Another theory is that these mound effigies were objects of religious significance, perhaps the mound itself being an object of worship or designating the place as a temple where ceremonies were performed in honor of the animal or to the spirits which it represented. Much literature has been written upon this subject into which we are not permitted to go with any very great detail.

It is possible that an emblematic system prevailed among the Mound Builders and that instead of this system being portrayed on the wooden structures, as with the Indians and the Eskimo, the totems were built into the soil and made expressive of the names or clans or gentes resident in the different places thus marked or designated.

LOCATION OF EFFIGY MOUNDS,

The selection of the location of these monuments may have been a mixed one. Perhaps because of accessibility to the neighboring clan; perhaps from the prominence of the site and perhaps of the peculiar

form of the site. The choice of location would some-
times indicate that even if animal worship was the
prime motive, it was in conjunction with nature wor-
ship, to which most savage peoples were given. The
nature of the location, its surroundings, scenery, etc.,
evidently were features in this matter. As one au-
thor points out, many primitive peoples were given to
what is known as scenery worship. The Chinese are
cited as an example of this. They had a .peculiar
superstition which in English was called geomancy;
the idea being that the scenery is haunted with cer-
tain spirits which are spirits of nature. In other
words, that there are certain occult influences which
prevail over earth, air, water, but particularly the
hills and the streams. These influences come into
connection with human destiny by gliding along the
summits of hills into groves or over the tall trees or
through the medium of any object in the landscape.

The conformation of the effigies, as evidenced in
many cases, to the shape of the ground is further sug-
gestive of animal worship. So strong was this tend-
ency in aboriginal peoples, to couple the scenes of na-
ture with animal divinities, that it led to "the trans-
formation of the formation of the earth by the aid of
art into shapes which would represent the animal di-
vinities to the eye." This transformed ground indi-

cates it is claimed that there was prevalent among the builders a primitive animism or belief that a personal life or soul abides in inanimate objects and in the phenomena of nature. There are many places where the effigies apparently conform to the shape of the ground, so that the natural and artificial are hardly distinguishable, both combining to represent the animal figure. The suggestion of the particular shape which should be given to the effigy would perhaps come from the natural contour of the ground, but the embodiments of the shape would be completed by the work of art. This appears to have been true of many of the effigy mounds in Wisconsin, according to Dr. Peet, who says on this subject:

"We have seen that the emblematic mounds contain figures of the animal divinities which this mysterious people worshipped, and that they picture before us the superstitious and religious conceptions which ruled, but there is that in the locations of the mounds which convinces us that their divinities were closely associated with the natural features of the earth and that they thus became remarkable exponents of nature worship. The most eloquent and expressive thing of all is that these emblematic shapes everywhere haunt us with their presence. The streams and lakes, hills and valleys, woods and prai-

ries, are overshadowed by their images. It seems
strange that the people should have formed such con-
ceptions, but especially strange that they should have
impressed their conceptions upon the works of nature.
The animals were divinities to them, but the animal
effigies were placed most conspicuously upon the face
of the earth and made to figure as symbols of these
divinities. There was in these effigies the union of the
three elements — the conspicuous location, the animal
semblance and the supernatural power. It was this
singular superstition which seized upon the most
prominent points of land and there placed the figures
of their animal divinities and made them preside over
the scene by a supernatural power. It is impossible
to go from group to group of these strange effigies and
see how closely they are associated with the natural
features without realizing that there was a religious
conception which exalted them to a level of a super-
natural presence."

NATURE OR ANIMAL WORSHIP.

In other words, savage peoples were given to two
forms of nature worship; (1) that of nature itself, the
hills, trees, rocks, streams, the scenery, and natural
phenomena as fire, lightning, thunder, rain, etc., be-
lieving all these things were animated by spirits that

could be propitiated by worship; (2) the worship of
the symbols of these, as the wooden totems or earthen
constructed effigies of animals. As these mound effi-
gies often appear to have been placed on sites natur-
ally, in form, suggesting the animal in question, or
on ground molded or transformed to suggest the ani-
mal, it is thought that these effigies so located and the
site selected for them present a double purpose or two-
fold religious motive, viz., nature worship direct and
symbolic worship. The Great Serpent seems to sin-
gularly answer to this "double play" in superstitious
nature worship, the natural mound itself suggesting
a great serpent, as so distinguished a scholar as Prof.
Holmes has clearly pointed out. Students of an-
thropology, ethnology and archaeology seem to agree
that among the earliest of religious beliefs is that of
animism or nature worship. Next to this in the ris-
ing scale is animal worship and following it is sun
worship. Animism is the religion of the savage and
wilder races, who are generally wanderers. Animal
worship is more peculiarly the religion of the sedent-
ary tribes and is incident to a condition where agri-
culture and permanent village life appear. Sun wor-
ship is the religion of the village tribes and is pecu-
liar to the stage which borders upon the civilized. It
is a religion which belongs to the status of barbarism,

but often passes over into the civilized state. "Now
judging from the circumstances and signs," says Dr.
Peet, "we should say that the emblematic Mound
Builders were in a transition state between the condi-
tions of savagery and barbarism and that they had
reached the point where animal worship is very prev-
alent. This habit of fixing upon the scenes of nature
and then transforming them into animal divinities is
evidence in our opinion that the old superstition that
nature was possessed by a spirit had given way to the
idea that animals were the objects of worship and were
haunted by divinities, was, however, still retained and
there is no doubt that many of the effigies which sur-
mount the hill tops perpetuated their local traditions
and were demonstrative of these traditions to the
peoples which inhabited the region. The question of
idolatry arises at this point whether the emblematic
Mound Builders erected their effigies as idols and re-
garded them as objects of worship or whether they
were simply symbolical, merely suggestive of spiritual
forces or religious emotions. There are to be sure many
localities where effigies are arranged so as to form a
sacred enclosure, and there are evidences that in these
enclosures religious rites were practiced; but it has
not yet appeared that the effigies were themselves thus
isolated and made objects of worship. This is an in-

teresting point. The location of the effigies some-
times gives the idea that a superstitious awe was felt
towards them, as if they were divinities presiding over
the scene, but it also shows that the effigies were de-
voted to familiar and practical uses, the divinity serv-
ing both as a guardian divinity and as a watch-tower
or lookout for the people. It is to be observed that
the cases are rare where an effigy is isolated and kept
at a distance, as if it were too sacred for approach.
This custom of erecting single effigies on isolated hill-
tops, where they could be seen, but owing to the dis-
tance and isolation could not be approached, was, as
we may say, common in other parts of the country. It
appears that the two effigy mounds found in Ohio,
namely, the serpent and the alligator, were thus situ-
ated. The alligator mound was erected on a high hill,
and overlooked the whole valley where are the works
which have been noted as the most extensive and com-
plicated of any in the country, namely, those at New-
ark. The location of this effigy — (alligator) — at the
head of the valley, on so prominent a hilltop, would
indicate that it was regarded with superstitious feel-
ing, and it may have been considered as a guardian
divinity for the whole region. It is possible that it
perpetuated some tradition which prevailed in the lo-
cality, and the hilltop and the effigy were associated

together, because of the tradition. The erection of
the altar near the effigy would indicate also that it
was a place where offerings were made, and would
suggest that the sacrifice had become formal, and pos-
sibly was conducted by a priesthood, rather than in

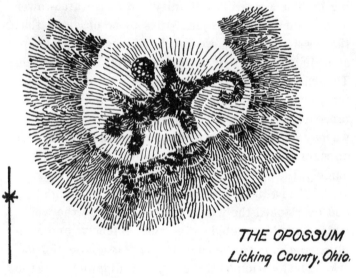

THE OPOSSUM
Licking County, Ohio.

the hands of individuals as voluntary. We cannot
say that this was true of the Great Serpent; and yet
the oval mound in front of the serpent effigy would
indicate that this also was used as a place of sacrifice,
and that here was a locality which tradition had fixed
upon as a place where some divinity had dwelt. We

suggest also in reference to this serpent mound, that possibly the very trend of the hill and of the valleys, and the streams on either side of it, may have given rise to the tradition. The isolation of the spot is remarkable. The two streams which here separate the tongue of land from the adjoining country unite just below the cliff, and form an extensive open valley, which lays the country open for many miles, so that the cliff on which the effigy is found can be seen to a great distance. The location of this effigy is peculiar. It is in the midst of a rough, wild region, which at the present is difficult to approach, and according to all accounts is noted for its inaccessibility.

"The shape of the cliff would easily suggest the idea of a massive serpent, and this with the inaccessibility of the spot would produce a peculiar feeling of awe, as if it were a great Manitou which resided there, and so a sentiment of wonder and worship would gather around the locality. This would naturally give rise to a tradition or would lead the people to revive some familiar tradition and localize it. This having been done, the next step would be to erect an effigy on the summit which should both satisfy the superstition and represent the tradition. It would then become a place where the form of the serpent divinity was plainly seen, and where the worship of the

serpent, if it can be called worship, would be practiced. Along with this serpent worship, however, there was probably the formality of a priestly religion, the rites of sacrifice having been instituted here and the spot made sacred to them. It was generally "sacrificing in a high place." The fires which were lighted would be seen for a great distance down the valley and would cast a glare over the whole region, producing a feeling of awe in the people who dwelt in the vicinity. The shadows of the cliff would be thrown over the valley, but the massive form of the serpent would be brought out in bold relief; the tradition would be remembered and superstition would be aroused, and the whole scene would be full of strange and aweful associations."

SERPENT WORSHIP.

The various authors who have treated of this serpent mound have maintained that the tradition which found its embodiment here was the old Brahmanic tradition of the serpent and the egg.

Mr. S. G. Squier connects the effigy with the serpent worship which is so extensive in different parts of the world, and Schoolcraft has expressed the opinion that it was a sign of the Hindoo myth, and

even Drake in his new volume on Indian tribes suggests the same.

"The superstition about the serpent is next to be considered. Here we come in contact with a very remarkable coincidence. The serpent effigy is found in Ohio, in Wisconsin and in Dakota, three places where the tribes of the Dakotas are supposed to have been located. There is the peculiarity about all of these, they are conformed to the shape of the land on which they are situated, the natural and artificial shape both giving the idea that the serpent divinity haunted the spot. Whether this is a conception which is peculiar to the Dakotas or not, it is a very remarkable coincidence that these effigies should appear in the places where the Dakotas have lived, and only in those places. There is another point to this matter. Dr. J. W. Phene discovered a ridge in Great Britain which had the serpent shape and along the ridge were placed a line of stones which represented the spine of the serpent. In digging into the hill a cist or altar was found near where the heart of the serpent would be. There are those who think that the Dakotas migrated from the east, and that they came into the continent from the northeast and were originally from Great Britain, Scandinavia or other northern parts of Europe. Here we have a singular

and novel confirmation of the theory. The Great Serpent in Adams County has an altar in the very center of the body* and the shape of the serpent corresponds to the shape of the ridge, the effigy having been placed upon the ridge because of its resemblance to the serpent. We claim priority in the discovery of this fact. We have only to imagine the fire lighted upon the altar on the top of the ridge, shooting its gleam up to the sky, casting fitful shadows over the valley below, and filling the whole scene with its mysterious glare, to realize how terribly the minds of the superstitious people would be impressed. The fire can be seen for several miles. The erection of an effigy of an immense serpent a thousand or twelve hundred feet long on this spot was in accord with the superstitions of the people. It was not strange that they should recognize the resemblance, for they seem to have been given to serpent worship, but the repetition of the practice of erecting serpent effigies in this way is remarkable. We do not know how they received this cult. The original home of the serpent worship is supposed to have been in India and yet it is spread from India to Great Britain and appears

* Dr. Peet seems to be in error about an altar being in the center of the body. There is no evidence of such nor does any other archæologist so claim so far as we can learn.

wherever the Indo-European race has trodden. Its introduction into this country may have been from Europe, via Iceland, Labrador and the northeast coast. The coincidences are so striking that we are inclined to say that it was a borrowed cult, yet there are those who maintain that it was indigenous to America." Dr. Peet, in his volume on "Emblematic Mounds and Animal Effigies," concludes that the effigy Mound Builders were the Dakotas or some branch of that Indian tribe or family. He bases his theory on the following:

"The facts which we have in mind, and which seem so to confirm our theory are as follows: 1. The migration of the Dakotas and the location of the effigy mounds correspond remarkably on the general map, the migrations have reached the several points where the effigies have been discovered. 2. The pictorial representations which are supposed to have belonged to the Dakotas and which are still found upon the rocks which are in the tracks of these migrations, have striking resemblances to the effigy mounds in their varied shapes. 3. The map of Wisconsin, the state in which the effigies are the most numerous, gives us some remarkable suggestions as to the reasons for the locating of the effigy-builders in the state, there being a striking correspondence between the topography of

the state and the different classes of mounds which are there found. 4. The map of each locality where effigies are found has some very important lessons as to the reasons for these particular effigies, as the location of the effigies reveals the very haunts of the animals, as well as their habits. 5. The last point is that which relates to the clans, the specific location of each clan being ascertained by an examination of a map of the mounds."

Dr. Peet then proceeds to present his authorities for the migrations of the Dakotas; their various locations and corresponding remains of effigy mounds, picture adorned rocks, etc. Confirmatory of this theory he cites the Indian dances* in which there is a combination of human and animal motions, dances frequently conducted in such a way as to imitate the motions of animals." He also thinks that the effigy

* It is a well known fact that many modern tribes of Indians indulged in "Snake Dances" in some of which live snakes "took part." The snakes even of a poisonous nature would be secured and placed within the dance ring and even be handled and fondled in the dance much after the description of the serpent ceremonies of the ancient oriental peoples. The writer saw one of these snake dances enacted by Western Indians at the Louisiana Purchase Exposition. Could it have been the hereditary custom handed down through innumerable generations from a prehistoric serpent worshipping race?

mound was representative of or suggested by the animal or bird most prevalent in the locality in question. Describing the effigy mounds of Wisconsin, he says: "As to the correspondence between the clan emblems and the animals which were the most abundant in the locality, a few words should be said. This correspondence has been noticed in several places. To illustrate: The turtle is the clan emblem at Beloit. Turtles are very common there, so common that Turtle Creek and Turtle Township are named after them. The same is true in Eagle Township. The name, the prevailing effigy and topography would show that it is a place where eagles formerly abounded. At Big Bend and West Bend there is the same correspondence, the region having been favorable for the panther in one place and the wolf in the other, both being in the midst of heavy forests. This would at first seem to work against the position that the effigies were clan emblems; but as we further consider it, we might ask why the particular emblems should be used rather than others. The prairie chicken, the duck, the wild goose, are just as common as the turtle, panther and wolf, but they never are made the prevailing emblem. At least they never exclude other figures. We have a hint here as to the **origin of the clan names. It would seem as if the**

habitat had been named, as well as the clan, and that the clans had been named after they had reached their permanent location, and that the other animals of the locality had given the name and emblem, the same custom prevailing in prehistoric times which is common in historic."

Dr. Peet, however, declares that the effigy mounds in Wisconsin and Ohio are prehistoric. If that be so, and it is almost universally admitted by archaeologists, they were built either by a race that preceded the Indians and had no relation to them or by a race remotely ancestral to the historic Indians. In either event would any knowledge we have of the migrations of the Dakotas or their kindred be conclusive evidence in this strange subject? We think not. Many students of the Mound Builders and of the Indians maintain that the Great Serpent Mound in Adams County is the product of Indian tribes who subsequently went west. Catlin, the celebrated Indian painter and student, who lived many years among the Indians, maintained as Dr. Peet states, "that the Mandans, who were a branch of the Dakotas, originally located in Ohio, the very region in which the Great Serpent is found, but that they migrated from that region, passing down the Ohio river and up the Missouri, and that they be-

came nearly extinct by the time they reached the head-waters of the Missouri. He has given a map with the route of the migration laid down on it, and the various stopping places designated."

WHO WERE THE MOUND BUILDERS?

A study of the literature put forth by the various archaeologists, more or less scholarly as the case may be, reveals of course no agreement among them as to the origin or race of the Mound Builders. Some maintain they are a branch of the Indian race, that they were the identical Indians we know or have known in history, the post-Columbian Indians; that they were Indians, but a generation or generations of the Indians that passed out of existence before the Indians we know anything about came upon the scene of action; *i. e.,* they were the ancestors more or less remote of the historic Indians; it is claimed in this connection that they were the descendants of the Mexican or South American Indians, perhaps of the Toltecs or Aztecs; again that they were the ancestors of the Mexican or South American Indians; again that they were the descendants or successors of earlier Indians who earlier or originally inhabited the great Northwest, having come perhaps from some Oriental race across Behring Strait; again it is maintained the

Mound Builders were a race entirely distinct and separate from the Indian race, having no relation remote or near to the people we call the American Indian. Dr. Peet's theory that the effigy Mound Builders were Dakota Indians or in some way related to them is only one phase of the various Indian theories. On this subject we may properly here insert the opinion of Prof. W. J. McGee, of the Bureau of Ethnology, Smithsonian Institution:

"The Serpent Mound is prehistoric. We do not know just how old it is, but we may judge that it is not more than 1,000 years old, nor less than 350 years. It was built, presumably, by the Indians who occupied that region at the time when it was first discovered by the whites. The white pioneers found the presumptive descendants of the builders of the Serpent Mound still in possession of the territory on which this mighty monument to their ancestors' religious faith had been erected.

"Of the important place which religion held in the lives of these people we may judge from the mighty monuments they left behind them as memorials of their faith. Much of their time was occupied by a series of elaborate ceremonials, celebrated annually, in the course of which they danced, feasted and busied themselves with the building of mounds. Quite fre-

quently these mounds were gigantic effigies of animals, and in this fashion they represented the bear, wolf, otter, eagle, crow and other animal "totems" or tutelaries of the class and tribes; the largest of all is the Serpent Mound in Adams County, Ohio, which is about 1,000 feet long.

"These effigy mounds do not seem to have been built for burial purposes. In the Serpent Mound nothing worth mentioning has ever been found. The mounds are purely symbolic. The snake was sacred, an object of veneration or worship; so, likewise, were the other animals represented. Savages commonly attribute to wild beasts special potencies, associating them with the supernatural, and extend toward them a kind of worship.

"It is probable that the building of the Serpent Mound extended over a number of years, and that the work was taken up annually, on the occasion of a certain festival. Thus it underwent a progressive enlargement and extension through a considerable period, the plan growing as the structure developed. Judging from the observed habits of Indians, the method of construction was simple, women bringing the earth in baskets on the backs, and the men managing and superintending the task. Incidentally there were feasting and dancing; it was all part of a

ceremonial corresponding in character to the "Gree Corn Dance" of the modern Iroquois or the "Dog Feast" of various Algonquin tribes." — Thus McGee.

MANY SERPENT MOUNDS.

Certain it is that the serpent was a well nigh common symbol or object with the Mound Builders. The snake effigy, as has already been noted, is found in various localities of the mound building territory. They exist in Ohio, Illinois, Minnesota, Wisconsin and Dakota. In Dakota a large stone serpent was constructed, "on a ridge which resembles a great serpent. It is a ridge which overlooks the prairie on all sides. The stones of which the serpent is composed brings out the resemblance, the two stones at the head of the serpent being very expressive." In Wisconsin serpent effigies existed at Mayville, at Green Lake, at Madison, at Potosi, near Burlington and elsewhere. According to Dr. Peet, each one of them corresponds to the shape of the ground on which it was placed, the natural and the artificial being always associated.*

* A most extensive and scholarly examination of the prehistoric mounds of Wisconsin was made by Mr. I. A. Lapham on behalf of the American Antiquarian Society. The results of his explorations were published in 1855 by the Smithsonian Institution, Washington, D. C. Mr. Lapham describes and illustrates in his

"The two serpents near Potosi, Wisconsin, are situated upon a ridge which in its shape is suggestive. Here the two serpents correspond with the shape of the cliff, every band of the cliff being followed by the effigy and the line which constitutes the summit being transformed by artificial means into the shape of serpents. It is quite wonderful, for the resemblance is so close that one is left in uncertainty after he has visited the locality whether he has not been deceived." A serpent effigy examined by Dr. Peet in Adams County, Illinois, also answers to the usual conformity of the site.

"The serpent effigy discovered by the author a few miles from his home in Adams County, Illinois, is also conformed to the tortuous shape of the cliff. This effigy is in a very conspicuous place. It overlooks the bottom lands of the Mississippi River for many miles. The effigy itself is a striking object.

work very many of the effigy mounds, which seem to have been almost innumerable in Wisconsin, the lizard appearing to have been the predominating and favorite figure. He does not seem to have identified any genuine serpents. He found many apparent artificial mounds, so constructed as to represent the snake, but most of these he proved upon examination to have been natural geological formations, some of them wonderfully resembling artificial structures.

The head of the serpent rests on the south end of the bluff. The bend of the neck follows the line of the bluff for 600 feet. The roll of the body extends 300 feet further, but is brought out more fully by four high conical mounds. The effigy then follows the line of the bluff for 600 feet or more, the rattles of the snake being plainly visible at the northern extremity of the bluff."

In connection with nearly every one of these serpent mounds, evidences, more or less clear and well preserved, exists of altar mounds, sometimes constructed of earth, more often of stones. This is undoubtedly true of the Great Serpent. In the center of oval, in front of the serpent's mouth, was found a pile of large stones, blackened with the effect of fire. Prof. Putnam speaks of it as follows: "Near the center of the enclosed area (the oval) is a small mound of stones, which was formerly much larger, since it was thrown down over fifty years ago by digging under it in search of supposed hidden treasure, the popular belief which has caused the destruction of many an ancient cairn. Many of the stones show signs of fire and under the cliff are similar burnt stones which were probably taken from the mound years ago."

From this hasty and fragmentary summary of the statements concerning the existence of the serpent

among the effigy mounds we may not accept as proven
any of the many theories concerning their origin or
their purpose, but we seem justified in the conclusion
that these serpent mounds were built with reference
to the religious life and the beliefs or superstitions of
the Mound Builders. The Mound Builders of the
Mississippi Valley were serpent worshippers. The
Ohio serpent is the greatest, most accurate and dis-
tinctively representative and now the most perfectly
preserved of all the snake mounds. When it was
built will doubtless always be a matter of conjecture
and dispute; certainly it existed centuries ago. This
we may safely decide from the evidence deducted from
the explorations of the serpent itself and the sur-
rounding mounds and village sites by the most dis-
tinguished archaeologist of our day.

ENGLISH AUTHORITIES.

Dr. Daniel Wilson, a most learned English au-
thority on archaeology and author of "Prehistoric
Man," (an extensive work in two volumes, published
in London, 1875) thus speaks of the Serpent Mound :
"The Great Serpent of Adams County, Ohio, occupies
the extreme point of a crescent-formed spur of land
formed at the juncture of two tributary streams of the
Ohio. This elevated site has been cut to a conformity

with an oval circumvallation on its summit, leaving a smooth external platform ten feet wide, with an inclination towards the embankment on every side. Immediately outside the inner point of this oval is the serpent's head, with distended jaws, as if in the act of swallowing what, in comparison with its huge dimensions, is spoken of as an egg, though it measures 160 feet in length. Conforming to the summit of the hill, the body of the serpent winds back, in graceful undulation, terminating with a triple coil at the tail. The figure is boldly defined, the earth-wrought relievo being upwards of five feet in height by thirty feet in base at center of the body; and the entire length, following its convolutions, cannot measure less than a thousand feet. This singular monument stands alone, and though classed here with the symbolic animal mounds of Wisconsin, it has no anologue among the numerous basso-relievos wrought on the broad prairie-lands of that region. It is indeed altogether unique among the earthworks of the New World and without a parallel in the Old; though it has not unnaturally furnished the starting point for a host of speculations relative to serpent worship."

Prof. James Fergusson, another famous English authority in archaeology, in his volume on "Rude Stone Monuments in All Countries," published in

London, 1872, when speaking of the animal mounds in America, thus disposes of the Serpent in Ohio:

"One of these, our authors (alluding to Squier and Davis) have no doubt, represents a serpent 700 feet long as he lies with his tail curled up into a spiral form, and his mouth gaping to swallow an egg (?) 160 feet long by 60 feet across. This at first sight looks so like one of Stukeley's monstrous inventions that the first impulse is to reject it as an illusion on the part of the surveyors. When, however, we bear in mind that the American Mound Builders did represent not only men, but animals, quadrupeds, and lizards, in the same manner, and on the same relative scale, all improbability vanishes. At the same time, the simple fact that the form is so easily recognizable here is in itself sufficient to prove that our straight-lined stone rows were not erected with any such intention, and could only be converted into Dracontia by the most perverted imagination.

"Though therefore we may assume that this mound really represents a serpent, it by no means follows that it was an idol or was worshipped. It seems to represent an action — the swallowing of something, but whether a globe or a grave is by no means clear, and must be left for further investigation. It is however, only by taking it in connection

with the other animal mounds in America that we can hope to arrive at a solution. They were not apparently objects of worship, and seem to have no connection with anything found in the Old World.

"The other mounds representing quadrupeds are quite unmistakable; they are a freak of this people whoever they were. But is seems difficult to explain why they should take this Brobdignagian way of representing the animals they possessed, or were surrounded by. If we knew more of the people, or of their affinities, perhaps the solution would be easy; at present it hardly interests us, as we have no analogue in Europe."

It will be interesting to note what is further said by so distinguished a scholar as Professor Fergusson, on the subject of the possible relation between the Mound Builders of America and the prehistoric people of the Old World; Prof. Fergusson continues: "It only now remains to try and ascertain if any connection exists or existed between these American monuments and those of the Old World; and what light, if any, their examination may be expected to throw in the problems discussed in the preceding chapters. If it is wished to establish anything like a direct connection between the two continents, we must go back to the far distant prehistoric times when the con-

formations of land and water were different from what they now are. No one, I presume, will be found to contend that, since the continents took their present shape, any migration across the Atlantic took place in such numbers as to populate the land, or to influence the manners or customs of the people previously existing there. It may be that the Scandinavians did penetrate in the tenth or eleventh centuries to Vinland, by the way of Greenland, and so anticipated the discovery of Columbus by some centuries; but this is only a part of that world-pervading energy of the Aryan races, and has nothing whatever to do with the people of the tumuli. If any connection really existed between the Old and New World, in anything like historic times, everything would lead us to believe that it took place *via* Behring Strait or the Aleutian Islands. It seems reasonable to suppose that the people who covered the Siberian Steppes with tumuli may have migrated across the calm waters of the Upper Pacific and gradually extended themselves down to Wisconsin and Ohio, and there left these memorials we now find. It may also be admitted that the same Asiatic people may have spread westward from the original hive, and been the progenitors of those who covered our plains with barrows, but beyond this no connection seems to be trace

able which would account for anything we find. Nowhere, however, in America do these people seem to have risen to the elevation of using even rude stones to adorn their tombs or temples. Nor do they appear to have been acquainted with the use of iron or of bronze; all the tools found in their tombs being of pure unalloyed native copper — both of which circumstances seems to separate these American Mound Builders entirely from our rude-stone people in anything like historic times. Unfortunately, also, the study of the manners and customs of the Red-man, who occupied North America when we first came in contact with them, is not at all likely to throw any light on the subject. They have never risen beyond the condition of hunters, and have no settled places of abode, and possess no works of art. The Mound Builders, on the contrary, were a settled people, certainly pastoral, probably to some extent even agricultural; they had fixed well chosen, unfortified abodes, altogether exhibiting a higher state of civilization than we have any reason to suppose the present race of Red-men ever reached or are capable of reaching. Although, therefore, it seems in vain to look on the Red Indians, who in modern times occupied the territories of Ohio and Wisconsin as the descendants of the Mound Builders, there are tribes

on the west coast of America that probably are, or rather were, very closely allied to them."

SQUIER AND DAVIS' ACCOUNT.

Many American archaeologists, perhaps the majority of the more distinguished ones, hold to the belief that the Mound Builders were the ancestors, how remote may not be known, of the historic or post-Columbian Indians. But a discussion of the relationship between the Mound Builders and the Indians is other than has been already set forth in these pages, beyond the purpose of this pamphlet concerning Serpent Mound. It was first discovered — within the knowledge of the present generation — by Squier and Davis, who surveyed and examined it in 1845, during their valuable explorations of the various mounds of Ohio. In their volume reporting the explorations of the "Ancient Monuments of the Mississippi Valley," which constitutes the first volume of the contribution to knowledge by the Smithsonian Institution, they describe Serpent Mound as follows:

"Probably the most extraordinary earthwork thus far discovered at the west, is the Great Serpent, of which a faithful delineation is given in the accompanying plan. It is situated on Brush Creek, at a point known as the "Three Forks," on Entry 1014,

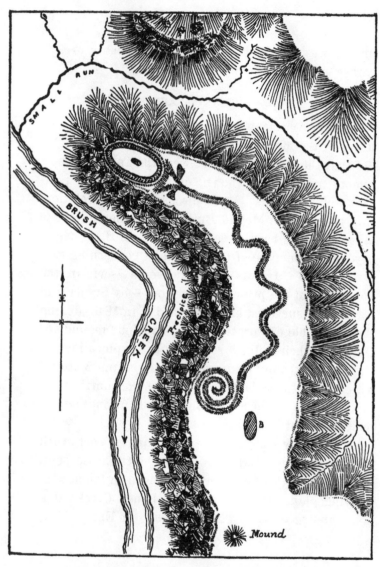

SQUIER AND DAVIS'S FIGURE OF THE SERPENT MOUND.

near the north line of Adams County, Ohio. No plan or description has hitherto been published; nor does the fact of its existence appear to have been known beyond the secluded vicinity in which it occurs. The notice first received by the authors of these researches was exceedingly vague and indefinite, and led to the conclusion that it was a work of defence, with bastions at regular intervals, a feature so extraordinary as to induce a visit, which resulted in the discovery here presented. The true character of the work was apparent on the first inspection.

"It is situated upon a high, crescent-form hill or spur of land, rising one hundred and fifty feet above the level of Brush Creek, which washes its base. The side of the hill next the stream presents a perpendicular wall or rock, while the other slopes rapidly, though it is not so steep as to preclude cultivation. The top of the hill is not level but slightly convex, and presents a very even surface, one hundred and fifty feet wide by one thousand long, measuring from its extremity to the point where it connects with the table land. Conforming to the curve of the hill, and occupying its very summit, is the serpent, its head resting near the point, and its body winding back for seven hundred feet, in graceful undulations, terminating in a triple coil at the tail. The entire length, if

extended would not be less than one thousand feet. The accompanying plan, laid down from accurate survey, can alone give an adequate conception of the outline of the work, which is clearly and boldly defined, the embankment being upward of five feet in height by thirty feet base, at the centre of the body, but diminishing somewhat towards the head and tail. The neck of the serpent is stretched out slightly curved, and its mouth is opened wide as if in the act of swallowing or ejecting an oval figure which rests partially within the distended jaws. The oval is formed by an embankment of earth, without any perceptible opening, four feet in height, and is perfectly regular in outline, its transverse and conjugate diameters being one hundred and sixty and eight feet respectively. The ground within the oval is slightly elevated. A small circular elevation of small stones much burned once existed in its centre; but they have been thrown down and scattered by some ignorant visitor, under the prevailing impression probably that gold was hidden beneath them. The point of the hill, within which this egg-shaped figure rests, seems to have been artificially cut to conform to its outline, leaving a smooth platform, ten feet wide, and somewhat inclining inwards, all around it.

Upon either side of the serpent's head extend two small triangular elevations. ten or twelve feet over. They are not high, and although too distinct to be overlooked, are yet too much obliterated to be satisfactorily traced. Besides a platform, or level oval terrace, and a large mound in the centre of the isthmus connecting the hill with the table land beyond, there are no other remains, excepting a few mounds, within six or eight miles, — none, perhaps, nearer than the entrenched hill in Highland County, thirteen miles distant. There are a number of works lower down on Brush Creek, towards its mouth; but their character is not known. The point on which this effigy occurs commands an extensive prospect, overlooking the 'bottoms' found at the junction of the three principal tributaries of the creek. The alluvial terraces are here quite extensive, and it is a matter of surprise that no works occur upon them.

"The serpent, separate or in combination with the circle, egg or globe, has been a predominant symbol among many primitive nations. It prevailed in Egypt, Greece, and Assyria, and entered widely into the superstitions of the Celts, the Hindoos, and the Chinese. It even penetrated into America; and was conspicuous in the mythology of the ancient Mexicans, among whom its significance does not seem to

have differed materially from that which it possessed in the Old World. The fact that the ancient Celts, and perhaps other nations of the old continent, erected sacred structures in the form of the serpent, is one of high interest. Of this description was the great temple of Abury, in England, — in many respects the most imposing ancient monument of the British Islands.

"It is impossible, in this connection, to trace the analogies which the Ohio structure exhibits to the serpent temples of England, or to point out the extent to which the symbol was applied in America, — an investigation fraught with the greatest interest both in respect to the light which it reflects upon the primitive superstitions of remotely separated people, and especially upon the origin of the American race." — Thus Squier and Davis.

SERPENT WORSHIP.

And still, with all this scholarly research and thoughtful study by archaeologists the Great Serpent Mound holds its secret silent and sacred as the grave.

Professor J. G. R. Forlong, of London, England, in a voluminous work of two octavo tomes entitled the "Rivers of Life; or Sources and Streams of the

Faith of Men in all Lands," published in London,"
1874, has made perhaps the most exhaustive ex-
amination of the origin of various religions and
forms of faith and worship ever made by one
student. Prof. Forlong demonstrates that the ear-
liest object of worship known to primitive man
was the *tree,* the most beautiful form of nature, sym-
bolical of the productive and living force of nature
growing from mother earth in symmetrical and ever
changing forms. The Tree worship was the first
form of nature worship leading directly to the wor-
ship of other objects of inanimate nature, the rocks,
the bushes and even sticks and inert objects. Mr.
Forlong says: "The second great deity, and to us in
this civilized and wholly changed state of existence,
strange and ever-horrible deity, is one still most prom-
inent — the *anguis in herba* — or mysterious 'stranger
in the grass,' who overcame with honey words the
fabled mother of us all, and who to the astonished
gaze of the primitive race, overcame by god-like
power, man, as well as the strongest beast of the field.
That as a mere reptile he was 'subtler,' as the story
says, than every other creature, has not since ap-
peared, but his subtle mode of approach, his daring
and upright dash, was pictured as god-like, and in

nearly all eastern countries he is still not only feared but worshiped as 'the God of our Fathers,' and the symbol of desire and creative energy."

CHARACTER OF THE SERPENT.

The worship of the serpent was undoubtedly the first form and ever after, even to this day, the predominating one in the religious rites bestowed upon animal life in general; the fear and reverence accorded animals primarily considered sacred or made so by gradually regarding them as endowed with supernatural powers finally embraced a great number of animal forms. But the "trail of the serpent" was over and above them all, in all races, all climes and all times. The serpent more than any other animate creature possesses properties of mystery and divinity. He moves "swift as a shadow" without hands, feet, wings or fins, on land or on water; without noise or warning; with the speed of an arrow he strikes his foe and pierces him with his death-dealing fangs; or envelopes his enemy no matter how large or strong in his resistless embrace and crushes the breath of life from his victim or swallows whole his prey that is transfixed by his charm or unaware of his silent approach; his colors are as variegated as the leaves of the forest; his movements graceful and weird; the

glow of his eye awful and enthralling; he assumes a variety of forms and figures; sheds his skin and comes forth renewed and rejuvenated; he is long lived; enlarges his size and strength; he is inspirited and fiery. Surely a creature with such anamalous powers was well calculated to arouse the awe, superstition, fear and reverence of the primitive ages. Says Forlong: "The serpent is the special Phallic symbol which veils the actual God, and therefore do we find him the constant early attendant upon Priapus or the Lingum, which I regard as the second religion of the world. It enters closely into union with all faiths to the present hour. We find him in the Vishnas, the Hindoos, and the tales of Vedic Avatars. He is God in eternity, the many coils of the snake representing infinitiveness and eternity, especially so as represented by the Egyptians with tail in mouth. There is no mythology or ancient sculpture in which the serpent does not bear a part. The universality of serpent worship has long been acknowledged by the learned. It is called Ophiolatry. It has been worshiped in the lowest strata of civilization. In Egypt we see the serpent under a multitude of symbols and connected with all sorts of worship; also in Assyria and India. We meet him in the wilderness of Sinai, the groves of Epidauraus, and in the Samothracian huts. In the case of

serpents the most wonderful legends and the few facts come down to use regarding their saliva, mode of coition, sperm, skin and egg. Pliny tells us in regard to the origin of the serpent egg that this is brought about by a bed or knot of snakes; that an infinite number entwine themselves together in the heat of summer, roll themselves into a mass, and from the saliva of their jaws and the froth of their bodies is generated an egg called anguinum and that by the violent hissing of the serpents this egg is forced into the air. The egg, or its priestly imitation, has always been much prized and was once revered by Kelts as an object of Druidical worship. The Keltic story of the production of the anguinum is like that given by Pliny. The snakes were said to meet at Beltime, join mouths and hiss until a bubble was produced; other snakes then hissed on this and blew it in a ring over the body of a snake when it at once hardened."

The worship of fire was third in the order of superstitious worship. Tree, serpent and fire worship existed in their origin in the order thus named, but in the early progress of man became contemporaneous worship. The sun worship was also one of the primary forms and while following the three named above became likewise coincident and after its intro-

duction is found with many races closely connected with the serpent worship.

BRYANT'S "ANCIENT MYTHOLOGY."

Perhaps the most accurate and authoritative work on the subject of serpent worship is the chapter on that topic by Jacob Bryant in his "Analysis of Antient Mythology," in five volumes, published in London in the year 1807. Mr. Bryant on the subject of serpent worship and its origin has this to say: "Oph signifies a serpent, and was pronounced at times and expressed, Ope, Oupis, Opis, Ops; and by Cicero, Upis. It was an emblem of the Sun; and also of time and eternity. It was worshipped as a diety, and esteemed the same as Osiris; by others the same as Vulcan. A serpent was also, in the Egyptian language, styled Ob, or Aub; though it may possibly be only a variation of the term above. We are told by Orus Apollo, that the Basilisk, or royal serpent, was named Oubaios. The Diety, so denominated, was esteemed prophetic; and his temples were applied to as oracular. This idolatry is alluded to by Moses, who, in the name of God, forbids the Israelites ever to inquire of those daemons, Ob and Ideone; which shows that it was of great antiquity. The symbolic worship

of the serpent was, in the first ages, very extensive; and was introduced into all the mysteries, wherever celebrated. It is remarked that wherever the Amonians founded any places of worship, and introduced their rites, there was generally some story of a serpent. There was a legend of a serpent at Colchis, at Thebes, and at Delphi; likewise in other places. The Greeks called Apollo himself Python, which is the same as Opis, Oupis, and Oub. The woman at Endor, who had a familiar spirit, is called Oub, or Ob; and it is interpreted as Pythonissa. The place where she resided, seems to have been named from the worship there instituted: for Endor is compounded of En-Ador, and signifies Fons Pythonis, the fountain of light, the oracle of the God Ador. This oracle was, probably, founded by the Canaanites; and had never been totally suppressed. In ancient times they had no image in their temples, but, in lieu of them, using conical stones or pillars, called *baitulia,* under which representation this Deity was often worshipped. His pillar was also called Abaddir, which should be expressed Abadir, being a compound of Ab, and Adir; and means the serpent Deity, Addir, the same as Adorus. It was also compounded with On, a title of the same Deity; and Kircher says that Obion is still, among the people of Egypt, the name of a serpent.

The same also occurs in the Coptic lexicon. The worship of the serpent was very ancient among the Greeks, and is said to have been introduced by Cecrops. But though some represent Opis as a distinct Deity; yet others introduce the term rather as a title, and refer it to more Deities than one: Callimachus, who expresses it Oupis, confers it upon Diana, and plays upon the sacred term. * * *

"It may seem extraordinary, that the worship of the serpent should have ever been introduced into the world; and it must appear still more remarkable, that it should almost universally have prevailed. As mankind are said to have been ruined through the influence of this being, we could little expect that it would, of all other objects have been adopted, as the most sacred and salutary symbol; and rendered the chief object of adoration. Yet so we find it to have been. In most of the ancient rites there is some allusion to the serpent. I have taken notice, that in the Orgies of Bacchus, the persons who partook of the ceremony used to carry serpents in their hands, and with horrid screams called upon Eva, Eva. They were often crowned with serpents, and still made the same frantic exclamation. One part of the mysterious rites of Jupiter Sabazius was to let a snake slip down the bosom of the person to be initiated, which was taken

out below. These ceremonies, and this symbolic wor-
ship, began among the Magi, who were the sons of
Chus: and by them they were propagated in various
parts. Epiphanius thinks, that the invocation, Eva,
Eva, related to the great mother of mankind, who was
deceived by the serpent; and Clemens of Alexandria
is of the same opinion. But I should think, that Eva
was the same as Eph, Epha, Opha, which the Greeks
rendered, Ophis, and by it denoted a serpent. Clem-
ens acknowledged, that the term Eva properly aspir-
ated had such a significance. Olympias, the mother
of Alexander, was very fond of these Orgies, in which
the serpent was introduced. Plutarch mentions, that
rites of this sort were practiced by the Edonian
women near Mount Maemus in Thrace; and carried
on to a degree of madness. Olympias copied them
closely in all their frantic manœuvres. She used to
be followed with many attendants, who had each a
thyrsus with serpents twined round it. They had
also a snake in their hair, and in the chaplets, which
they wore; so that they made a most fearful appear-
ance.* Their cries were very shocking: and the whole

* Many readers will remember that a few years ago there
swept over the country among the "four hundred" the fad of se-
curing a tiny species of lizard, brilliant colored of the chameleon
variety, which the silly dames would attach by gold chains to their

was attended with a continual repetition of the words, Evoe, Saboe, Hues Attes, Attes Hues, which were titles of the God Dionusus. His priests were the Hyades, and Hyantes. He was likewise styled Evas.

"In Egypt there was a serpent named Thermuthis, which was looked upon as very sacred; and the natives are said to have made use of it as a royal tiara, with which they ornamented the statues of Isis. We learn from Diodorus Siculus, that the kings of Egypt wore high bonnets, which terminated in a round ball; and the whole was surrounded with figures of asps. The priests likewise upon their bonnets had the representation of serpents. The ancients had a notion, that when Saturn devoured his own children, his wife Ops deceived him by substituting a large stone in lieu of one of his sons, which stone was called Abadir. But Ops, and Opis, represented here as a feminine, was the serpent Deity, and Abadir is the same person-

bosoms. It was "quite the thing," you know, for these ultra fashionable ladies to wear these little captives, thus permitted to crawl about their necks and shoulders, not only at the swell dinners and high teas but even in public upon the street. A singular illustration, in view of the statement related above, that history repeats itself. These lizard-adorned women were simply reviving the fashion originally set by Mrs. Olympias, the mother of Alexander the Great.

age under a different denomination. Abadir seems to have been a variation of Ob-Adur, and signifies the serpent God Orus. One of these stones, which Saturn was supposed to have swallowed instead of a child, stood, according to Pausanias, at Delphi. It was esteemed very sacred, and used to have libations of wine poured upon it daily; and upon festivals was otherwise honoured. The purport of the above history I imagine to have been this. It was for a long time a custom to offer children at the altar of Satan: but in process of time they removed it, and in its room erected a stone pillar; before which they made their vows, and offered sacrifices of another nature. This stone, which they thus substituted, was called Ab-Adar, from the Deity represented by it. The term Ab generally signifies a father: but, in this instance, it certainly relates to a serpent, which was indifferently styled Ab, Aub, and Ob. I take Abadon, or, as it is mentioned in the Revelations, Abaddon, to have been the name of the same Ophite God, with whose worship the world had been so long infected. He is termed by the Evangelist, the angel of the bottomless pit; that is, the prince of darkness. In other place he is described as the dragon, that old serpent, which is the devil, and Satan. Hence I think, that the learned Heinsius is very right in the opinion, which

he has given upon this passage; when he makes Abaddon the same as the serpent Pytho.

"It is said that, in the ritual of Zoroaster, the great expanse of the heavens, and even nature itself, was described under the symbol of a serpent. The like was mentioned in the Octateuch of Ostanes; and moreover, that in Persia and in other parts of the east they created temples to the serpent tribe, and held festivals to their honour, esteeming them, the supreme of all Gods, and the superintendents of the whole world. The worship began among the people of Chaldea. They built the city Opis upon the Tigris, and were greatly addicted to divination, and to the worship of the serpent. From Chaldea the worship passed into Egypt, where the serpent Deity was called Canoph, Can-Eph and C-neph. It had also the name of Ob, or Oub, and was the same as the Basiliscus, or Royal Serpent; the same also as the Thermuthis; and in like manner was made use of by way of ornament to the statues of their Gods. The chief Deity of Egypt is said to have been Vulcan, who was also styled Opas, as we learn from Cicero. He was the same as Osiris, the Sun; and hence was often called Ob-El, or Python Sol; and there were pillars sacred to him with curious hieroglyphical inscriptions, which had the same name. They were very lofty, and

narrow in comparison of their length; hence among the Greeks, who copied from the Egyptians, every thing gradually tapering to a point was styled Obelos,

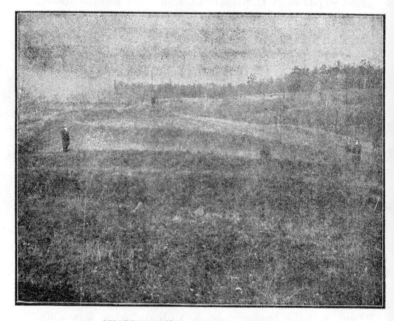

SERPENT MOUND — CENTER CONVOLUTIONS.

and Obeliscus. Ophel (Oph-El) was a name of the same purport; and I have shown, that many sacred mounds, or Tapha, were thus denominated from the serpent Deity, to whom they were sacred.

"Sanchoniathon makes mention of an history, which he once wrote upon the worship of the serpent. The title of this work, according to Eusebius was, Ethothion, or Ethothia. Another treatise upon the subject was written by Pherecydes Syrus, which was probably a copy of the former; for he is said to have composed it from some previous accounts of the Phenicians. The title of this book was the Theology of Ophion, styled Ophioneus; and of his worshippers, called Ophionidae. Thoth, and Athoth, were certainly titles of the Deity in the Gentile word; and the book of Sanchoniathon might very possibly have been from hence named Ethothion, or more truly Athothion. But from the subject, upon which it was written, as well as from the treatise of Pherecydes, I should think, that Athothion, or Ethothion, was a mistake for Ath-ophion, a title which more immediately related to that worship, of which the writer treated. *Ath* was a sacred title, as I have shown; and I imagine, that this dissertation did not barely relate the serpentine Deity; but contained accounts of his votaries, the Ophitae, the principal of which were the sons of Chus. The worship of the serpent began among them; and they were from thence denominated Ethopians, and Aithopians. It was a name, which they did not receive from their complexion, as has

been commonly surmised; for the branch of Phut,
and the Lubim, were probably of a deeper die: but
they were so called from Ath-Ope, and Ath Opis, the
God which they worshipped. This may be proved by
Pliny. He says that the country Aethiopia (and con-
sequently the people) had the name Aethiop from a
personage who was a Deity. The Aethiopes brought
these rites into Greece: and called the island, where
they first established them, Ellopia, Solis Serpentis
insula. It was the same as Euboea, a name of the
like purport; in which island was a region named
Aethiopium. Euboea is properly Oub-Aia; and sig-
nifies the Serpent-Island. The same worship pre-
vailed among the Hyperboreans, as we may judge
from the names of the sacred women, who used to
come annually to Delos. They were priestesses of
the Tauric Goddess, and were denominated from her
titles. Hercules was esteemed the chief God, the
same as Chronus; and was said to have produced the
Mundane egg. He was represented in the Orphic
Theology under the mixed symbol of a lion and a
serpent; and sometimes of a serpent only. I have be-
fore mentioned that the Cuthites under the title of
Heliadae settled at Rhodes: and, as they were Hivites
or Orphites, that the island in consequence of it was
of old named Ophiusa. There was likewise a tradi-

tion, that it was once swarmed with serpents. The like notion prevailed almost in every place, where they settled. They came under the more general titles of Leleges and Pelasgi; but more particularly of Elopians, Europians, Oropians, Asopians, Inopians, Ophionians, and Aethiopes, as appears from the names, which they bequeathed; and in most places, where they resided, there were handed down traditions, which alluded to their original title of Ophites. In Phrygia, and upon the Hellespont, whither they sent out colonies very early, was a people styled the serpent-breed; who were said to retain an affinity and correspondence with serpents. And a notion prevailed, that some hero, who had conducted them, was changed from a serpent to a man. In Chilchis was a river Ophis; and there was another of the same name in Arcadia. It was so named from a body of people, who settled upon its banks, and were said to have been conducted by a serpent. These reptiles are seldom found in islands, yet Tenos, one of the Cyclades, was supposed to have once swarmed with them. Thucydides mentions a people of Aetolia called Ophionians: and the people of Apollo at Patara in Lycia seem to have had its first institution from a priestess of the same name. The island of Cypress was styled Ophiusa, and Ophiodes, from the serpents, with which

it was supposed to have abounded. Of what species
they were is nowhere mentioned; excepting only that
about Paphos there was said to have been a kind of
serpent with two legs. By this is meant the Ophits
race, who came from Egypt, and from Syria, and got
footing in this island. They settled also in Crete,
where they increased greatly in numbers; so that
Minos was said by an unseemly allegory *serpentes
minxisse.* The island of Seriphus was one vast rock,
by the Romans called saxum serphium; and made use
of as a larger kind of prison for banished persons. It
is represented as having once abounded with serpents;
and it is styled by Virgil *serpentifera.* It had this
epithet not on account of any real serpents, but ac-
cording to the Greeks from Medusa's head, which was
brought hither by Perseus. By this is meant the ser-
pent Deity, whose worship was here introduced by
people called Peresians. Medusa's head denoted de-
vine wisdom: and the island was sacred to the ser-
pent, as is apparent from its name. The Athenians
were esteemed Serpentigenae; and they had a tradi-
tion, that the chief guardian of their Acropolis was
a serpent. It is reported of the Goddess Ceres, that
she placed a dragon for a guardian to her temple at
Eleusis; and appointed another to attend upon Erec-
theus. Aegeus of Athens, according to Androtion,

was of the serpent breed: and the first king of the country is said to have been a Dragon. Others make Cecrops the first who reigned. He is said to have been of a twofold nature; being formed with the body of a man blended with that of a serpent. Diodorus says that this was a circumstance deemed by the Athenians inexplicable: yet he labours to explain it, by representing Cecrops, as half a man and half a brute; because he had been of two different communities. Eustathius likewise tries to solve it nearly upon the same principles, and with the like success. Some had mentioned of Cecrops, that he underwent a metamorphosis, that he was changed for a serpent to a man. By this was signified, according to Eustathius, that Cecrops, by coming into Helles, divested himself of all the rudeness and barbarity of his country, and became more civilized and humane. This is too high a compliment to be paid to Greece in its infant state, and detracts greatly from the character of the Egyptians. The learned Marsham therefore animadverts with great justice. It is more probable, that he introduced into Greece, the urbanity of his own country, than that he was beholden to Greece for any thing from thence. In respect to the mixed character of this personage, we may, I think, easily account for it. Cecrops was certainly a title of the Deity, who was

worshipped under this emblem. Something of the like nature was mentioned of Triptolemus, and Ericthenius: and the like has been said above of Hercules. The natives of Thebes in Boeotia, like the Athenians above, esteem themselves of the serpent race. The Lacedaemonians likewise referred themselves to the same original. Their city is said of old to have swarmed with serpents. The same is said of the city of Amyclae in Italy, which was of Spartan original. They came hither in such abundance, that it was abandoned by the inhabitants. Argos was infested in the same manner, till Apis came from Egypt, and settled in that city. He was a prophet, the reputed son of Apollo, and a person of great skill and sagacity. To him they attributed the blessing of having their country freed from this evil. Thus Argives gave the credit to this imaginery personage of clearing their land of this grievance: but the brood came from the very quarter from whence Apis was supposed to have arrived. They were certainly Hivites from Egypt: and the same story is told of that country. It was represeuted as having been of old overrun with serpents; and almost depopulated through their numbers. Diodorus Siculus seems to understand this literally: but a region, which was annually overflowed, and that too for so long a season, could

not well be liable to such a calamity. They were serpents of another nature, with which it was thus infected: and the history relates to the Cuthites, the original Ophitae, who for a long time possessed that country. They passed from Egypt to Syria, and to the Euphrates: and mention is made of a particular breed of serpents upon that river, which were harmless to the natives, but fatal to every body else. This, I think, cannot be understood literally. The wisdom of the serpent may be great; but not sufficient to make this distinction. These serpents were of the same nature as the birds of Diomedes, and the dogs in the temple of Vulcan: and these histories relate to Ophite priests, who used to spare their own people, and sacrifice strangers, a custom which prevailed at one time in most parts of the world. I have mentioned that the Cuthite priests were very learned: and as they were Ophites, whoever had the advantage of their information, was said to have been instructed by serpents. Hence there was a tradition, that Melampus was rendered prophetic from a communication with with these animals. Something similar is said of Tiresias.

"As the worship of the serpent was of old so prevalent, many places, as well as people from thence, received their names. Those who settled in Cam-

pania were called Opici; which some would have changed to Ophici; because they were denominated from serpents. But they are, in reality, both names of the same purport, and denote the origin of the peo-

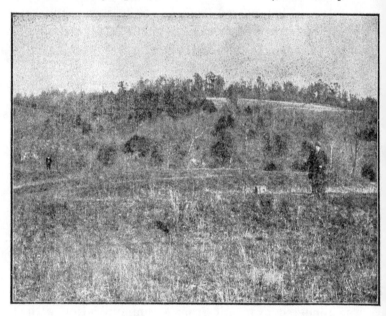

SERPENT MOUND — NEAR THE TAIL.

ple. We meet with places called, Opis, Ophis, Ophitaea, Ophionia, Ophioëssa, Ophiodes, and Ophiusa. This last was an ancient name, by which, according to Stephanus, the islands of Rhodes, Cythnus, Besbicus,

Tenos, and the whole continent of Africa, were dis-
tinguished. There were also cities so called. Add to
these places denominated Oboth, Obona, and reversed
Onobo, from Ob, which was of the same purport.
Clemens Alexandrinus says, that the term Eva sig-
nified a serpent, if pronounced with a proper aspirate.
We find that there were places of this name. There
was a city Eva in Arcadia: and another in Macedo-
nia. There was also a mountain Eva, or Evan, taken
notice of by Pausanias, between which and Ithome
lay the city Messen. He mentions also an Eva in Ar-
golis, and speaks of it as a large town. Another name
for a serpent, of which I have as yet taken no notice,
was Patan, or Pitan. Many places in different parts
were dominated from this term. Among others was
a city in Laconia; and another in Mysia, which Steph-
anus styles a city of Aeolia. They were undoubtedly
so named from the worship of the serpent, Pitan: and
had probably Dracontia, where were figures and de-
vices relative to the religion which prevailed. Ovid
mentions the latter city, and has some allusions to
its ancient history, when he describes Medea as fly-
ing through the air from Attica to Colchis. The city
was situated upon the river Eva or Evan, which the
Greeks rendered Evenus. It is remarkable, that the
Opici, who are said to have been denominated from

serpents, had also the name of Pitanatae: at least
one part of that family were so called. Pitanatae is
a term of the same purport as Opici and relates to
the votaries of Pitan, the serpent Deity, which was
adored by that people. Menelaus was of old styled
Pitanates, as we learn from Hesychius: and the rea-
son of it may be known from his being a Spartan, by
which was intimated one of the serpentigenae, or
Ophites. Hence he was represented with a serpent
for a device upon his shield. It is said that a brigade,
or portion of infantry, was among some of the Greeks
named Pitanates; and the soldiers, in consequence of
it, must have been termed Pitanatae: undoubtedly,
because they had the Pitan, or serpent, for their
standard. Analogous to this, among other nations,
there were soldiers called Draconarii. I believe, that
in most countries the military standard was an em-
blem of the Deity there worshipped.

"From what has been said, I hope, that I have
thrown some light upon the history of this primitive
idolatry: and have moreover shown, that wherever
any of these Ophite colonies settled, they left behind
from their rites and institutes, as well as from the
names, which they bequeathed to places, ample memo-
rials, by which they may be clearly traced out. It
may seem strange that in the first ages there should

have been such a universal deflection from the truth; and above all things such a propensity to this particular mode of worship, this mysterious attachment to the serpent. What is scarce credible, it obtained among Christians; and one of the most early heresies in the church was of this sort, introduced by a sect, called by Epiphanius Ophitae, by Clemens of Alexandria Ophiani. They are particularly described by Tertullian, whose account of them is well worth our notice. In this account we see plainly the perverseness of human wit, which deviates so industriously; and is ever after employed in finding expedients to countenance error, and render apostasy plausible. It would be a noble undertaking, and very edifying in its consequences, if some person of true learning, and a deep insight into antiquity, would go through with the history of the serpent. I have adopted it as far as it relates to my system, which is, in some degree, illustrated by it." — Thus Bryant.

REV. DEANE'S THEORY.

Following the extended account of Jacob Bryant we close our examination of the leading authorities on the Serpent Mound and the Serpent Worship by a copious reference to a most interesting work on "The Worship of the Serpent," traced throughout the world

by Rev. John B. Deane of Cambridge University, England. This work was published in London in 1833. The author is a strictly orthodox theologian and writes this book to "attest the temptation and fall of man by the instrumentality of a serpent tempter." Dr. Deane attempts to establish by the testimony of heathen authorities the credibility of the Biblical account of the temptation of Adam and Eve in Paradise through the agency of Satan, who, he believes, literally assumed the form of a serpent. The argument of his treatise is that the Creator made the first, and only original pair, Adam and Eve. From them descended all other races, peoples and nations. The knowledge of the temptation of the parent pair and the important role in that awful event enacted by the serpent was an historical fact handed down from generation to generation and as the race separated and became different, nations scattered in diverse parts of the world — each distinct branch preserved and cherished the tradition of the fall of man through the serpent, and the serpent was ever a god for good or evil to be propitiated by worship. Serpent worship was therefore universal. Ophiolatreia or Ophiolatry "existed in almost every considerable country of the ancient world," and all traditions of the serpent and forms of his worship must have had a common origin.

"The most ancient record containing this basis, is the Book Genesis, composed by Moses, which book therefore contains the history upon which the fables, rites and superstitions of the mythological serpent are founded." Mr. Deane clearly and with painstaking detail maintains the worship of the serpent commenced in Chaldea in the astronomy of which country and also of China authentic record of serpent worship is to be found. But this worship is also found in countries "where Chinese wisdom never penetrated and where Chaldean philosophy was feebly reflected." Indeed the author claims the serpent worship advanced from "Paradise to Peru." Mr. Deane then takes up in turn each country in which the serpent worship was found, traces its origin and history, citing and often quoting the early authorities and sacred books that sustain his argument. In his most scholarly and informing book he traces the serpent worship through Babylonia, Assyria, Persia, Hindustan, Ceylon, China, Japan, Phoenicia, Java, Arabia, Syria, Asia, Scythia, the Pacific Islands, Egypt, Ethiopia, Abyssinia, Congo, Greece, Espirus, Thrace, Italy, Sarmatia, Scandinavia, Britain, Ireland, Gaul, Brittany, Mexico, and Peru. He examines all the leading fables illustrative of the Fall of Man and the participation of the serpent therein; the legends of the

early natives as well as their forms of serpent worship. He describes the serpent temples of the various countries where they existed, and finally he recounts the decline and extinction of the serpent worship.

Dr. Deane concludes that the serpent worship was the only universal idolatry and that it preceded Polytheism; that the serpent was the most ancient of heathen gods, "and that as his attributes were multiplied by superstitious devotion, whose names were invented to represent the new personifications which, in the progress of time, divided the unity, destroyed the integrity of the original worship. Yet each of these prehistoric superstitions bore some faint trace of its draconic (draco, Latin for dragon or serpent) origin, in retaining the symbolical serpent. Some of these deifications may be easily traced, though others are obscure and difficult."

Such in brief is the summary of the subject of Serpent Worship by Rev. John B. Deane. He does not touch upon the American Mound Builders. But the writings of Bryant, Fergusson, Forlong, Deane and many others on the universality of serpent worship leads to an almost inevitable logic that the Great Serpent is surely the proof and manifestation that the Mound Builders were serpent worshippers and this

great earth relic was their idol or temple for that worship.

CURIOUS THEORIES.

This subject, in connection with the Serpent Mound, has its amusing and ridiculous features. Many curious and fantastic ideas are put forth concerning the Great Serpent; for example one writer holds that this Serpent Mound was in the midst of the Garden of Eden, which is thus located in Adams County, Ohio, instead of on the banks of the Euphrates (?). We reproduce the Garden of Eden fancy from the publication of the Ohio State Archaeological and Historical Society.

THE SERPENT MOUND, THE HOME OF ADAM AND EVE.

Here is food for the "higher critics," the Egyptologists, archaeologists and the Biblical students of all classes. The Garden of Eden, it seems, is now definitely located. The site is in Ohio, "Adams" County, to be more precise. The discoverer is the Rev. Mr. Landon West of Pleasant Hill, Ohio.

The famous Serpent Mound of Ohio is the key to the whole discoverey, according to Mr. West, whose account was published in the New York Herald. No object that has ever been discovered pos-

sesses for achaeologists such intense and varied interest as this curious earthwork. Since 1849, when it was first accurately surveyed by Messrs. Squier and Davis, it has been a mecca of archaeologists from all parts of the world. Volumes have been written about it, and every theory conceivable by the mind of man has been advanced as to the purpose of the vast work. Now, it has a new and vivid interest.

It has been called a shrine and an altar, a cemetery and a place for worship, it has been shown to be an idol and a place where human beings were sacrificed — all to the perfect satisfaction of the learned persons making the various guesses.

The character of this mound is so unique and totally different from any of the other remains of earthworks left by the so-called Mound Builders that every utterance made in relation to it instantly attracts the notice of the scholars. Professor Putnam of Harvard University prepared an exhaustive account of the mound and gave his theory as to its significance. It was through his efforts that the mound was saved from total destruction. In 1887 he visited it for the first time and was powerfully impressed with its tremendous significance. He impressed the college authorities with the value of the mound, and later it passed into the possession of the college.

Later, in 1889, it was formally presented by Harvard college to the State Archaeological and Historical Society of Ohio.

Professor Putnam conducted extensive explorations in the hope of learning the true character and significance of the work and made examinations which revealed something of the great age of the mound. It was held by some that undoubtedly it was old before the Chinese wall was built, and that it was finished and disintegrating when the children of Israel slaved in Egypt. It is also probable, judging from the condition of the soil that covers the figure, that it was part of the "things universal" that were overwhelmed by the flood.

The Rev. Landon West of Pleasant Hill, Ohio, a prominent and widely known minister of the Baptist church, has just outlined a theory concerning the creation and significance of the mound widely different from all those of the scientists. He believes that the mound itself was created by the hand of the Creator of the World, and that it marks the site of the Garden of Eden. He believes that the mound is purely symbolical and has no significance relative to the religion or worship of any race of men, but it intended to teach by object lesson the fall of man and the consequences of sin in the Garden of Eden.

The Rev. Mr. West was born and lived to manhood near the mound. Early in life he conceived the idea that the mound was not an object of worship nor a place of sacrifice, nor for interment, nor yet a spot where the tribes of the earth came together to discuss the affairs of the primitive nations. He conceived it to be a mighty object lesson to give expression to some great event that had occurred in the history of mankind. If intended for an object lesson, its meaning was too plain and palpable for discussion or argument. Plainly it was meant to illustrate the "first sad event" in the Garden of Eden, the deception of the woman by the serpent, and the man's subsequent expulsion from the Garden and all the attendant ills of sin, pain and death. All of these, he maintains, are adequately expressed by this Serpent Mound.

The jaws of the serpent are wide open, as if in the act of swallowing the oval-shaped fruit there situated. The Rev. Mr. West declares that it represents the fruit with which Satan beguiled and tempted Eve. It is a very good representation of a gigantic plum or lemon or some such fruit as grows upon a tree. The Bible refers to the fruit of the tree with which Satan, that old serpent, did tempt Eve by telling her it was good to eat. How could this very idea and circumstances of deception be better represented

on the part of the serpent, inquires this scholar, than to show it in the act of itself eating fruit, when it is well known that serpents do not eat fruit? The Rev. Mr. West maintains that the situation of this oval objects, which scientists term an altar, at the wide open jaws of the serpent would appear to deny their claim that it is an altar. Reason indicates a contrary theory; that the open jaws were meant to betray the purpose of the serpent to swallow the fruit. Else why should the jaws be open? The only meaning of the open jaws, he asserts, is to show the intention of the serpent to swallow the fruit. This portion of the mound represents the deception; the writhings and twisting of the body indicate the pangs of death and physical suffering.

It would seem that this perplexing and mysterious image was created to express an idea, and is, therefore, purely symbolical. What it symbolizes can be surmised only from the image itself and any supporting history that may be found. If it be conceded that the serpent mound is symbolical of man's fall in the Garden of Eden, and the Rev. Mr. West after years of study, is confident that it expresses no other lesson, then the question arises, how did this prehistoric race obtain knowledge of that event?

The Rev. Mr. West arrives at the conclusion that this great work was created either by God himself or by man inspired by Him to make an everlasting object lesson of man's disobedience, Satan's perfidy and the results of sin and death. In support of this startling claim the Rev. Mr. West quotes Scripture and refers to Job 16:13: "By His spirit He hath garnished the heavens; His hand hath formed the crooked serpent."

He also applies the discoveries of Professor Putnam to establish his theory. Professor Putnam learned that the depth of soil on the image was equal to that covering the surrounding country and was of similar properties and composition. This important discovery justified the statement that the work itself had been created prior to the formation of the soil which now covers the earth. This discovery, however, by no means fixes the time of the serpent's creation. It merely establishes the fact that the soil covering the image had never been disturbed by the hand of man. The tremendous ridge which constitutes the superstructure, if it may be so called, must have been formed long before the beginning of the slow process of the soil formation by nature in her never ending task of creation.

The noble dimensions and perfect proportions of this majestic figure suggest to his mind the hand and intelligence of a divine Creator with limitless resources. It is on a high ridge or rocky cliff that thrusts itself into the peaceful and lovely valley like the prow of some mighty ship into a calm sea. The ridge points to the north and extends back into a smiling land suggestive of peace, happiness and security. The head of the serpent lies upon the point of rock and the winding coils of the body reach back a thousand feet to the south, where the tail terminates in coils thrice repeated. The oval object, representative of the forbidden fruit, is a hundred feet long and has a depression in the center. The size of the jaws is proportionate to the size of the figure, exact as in nature, which has been ascertained by measurements of living serpents. The surrounding country is beautiful beyond description. Rich valleys stretch away beside three shining streams, which converge near the great serpent. These three streams are interpreted as typical of the Holy Trinity — Father, Son and Holy Spirit.

The image portrays the deception in the attitude of the serpent in the act of eating fruit; pain and death are shown by the convolutions of the serpent, just as the living animal would portray pain and

death's agony. The third chapter of Genesis is the only written history the world has of the fall of man and the cause that brought about his ruin. There are other references to it in the prophecies and revelations and all of these accounts agree and compare in a singularly close way, this student says, with the lesson imparted by the great serpent. That this remarkable conformity could have been effected by beings ignorant of the great lessons actually symbolized, Mr. West holds, is ridiculous. That the image antedates the arrival on this continent of any European discoverer who could have brought the story of the creation and of man's fall is likewise an assured fact, he declares.

After many years he learned that the Bible nowhere says that the Garden of Eden was located in Asia, and that its statements will not conflict with the theory that the Garden was actually in the Western hemisphere. The events of Eden occurred at a very early time in the history of the world, long before the time described by any historian. Moses is the only writer of history who described the Garden of Eden and the events that occurred therein. The time when he wrote was 2,500 years after the creation. He received this information from no written word, but from the inspiration of the Lord. No man was alive

who knew it before Moses. The Rev. Mr. West affirms it to be his belief that the figure of the serpent was drawn by the hand of the Creator, and that America is, in fact, the land in which Eden was located. Note Genesis 2:8; II Kings 19:12; Ezekiel 27:23, 31:8, and 29:18.

A curious and not unimportant consideration in connection with the mound is the fact that a crook was made in the northern line in the county containing the figure in order that the entire work might be contained within the county, which was established in 1790.

This figure, says Rev. Mr. West, is the most ancient record of history known to exist. It shows first sin and its immediate results as Moses also records them, and up to the time of the flood, which occurred in the year of the world 1655, it gave an actual object lesson and record of Eden and its events. But after the flood and until Moses, in the year 2500, the record of the creation, of the fall of man, of death, and of the flood, as well as of all other events retained till now of the history of the world, was taught and obtained only by tradition. Yet during all that time this perfect illustration of thought and of history was in existence, created beyond doubt to portray the one sad event to mark the spot where God's Word

and that form of teaching were first given to the human family. All that Job says of the event he learned by tradition, and no less than 2500 years after its occurrence.

All that education, science, history, revelation and act can do to illustrate the thoughts of intelligent beings either on earth or in heaven has not been found to excel in clearness this serpent image in setting forth the one event in Eden's garden.

This serpent figure was made long before the first copy of God's book was printed, yet it supports the written or inspired history of the human race. Will any one say that those who designed the serpent mound did not have in mind the event of sin and death as it occurred in the Garden of Eden?

Prof. J. P. MacLean, author of many books and formerly secretary of the Western Reserve Historical Society, in his book on "The Mound Builders," gives a condensed description of Serpent Mound, concerning which he claims to have made the discovery that upon the immediate brow of the cliff and in front of the egg or oval there is another animal mound in the form of a frog. His theory is that the frog has just laid the egg which is dropping into the mouth of the serpent, while the frog is about to leap from the cliff to the abyss below. His account is as follows:

"The most noted of all this class of remains is
the Great Serpent, located on entry 1010, Bratain
Township, Adams County, Ohio. It occupies the
entire summit of a crescent tongue of land, ris-
ing about one hundred feet above Brush Creek,

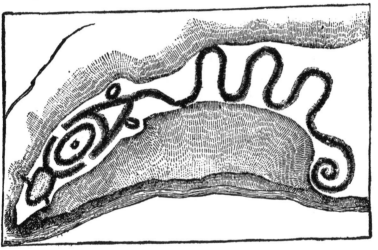

M'LEAN'S FIGURE OF THE SERPENT MOUND.

which washes it base. We have here a series of effigy
works, consisting of a frog, an egg, and a serpent.
The extreme point of the spur is perpendicular, rising
forty feet. The face of the rock on the summit is de-
nuded. Thirty feet from the point of rock the head of
the frog begins. This effigy, from its nose to the joint

formed by the joining of the hind legs, is thirty-five feet. The head is down, the fore legs extended, the hind legs pointing back as though it was in the act of leaping. Partially between the legs is an oval mass of earth one hundred and thirteen feet long by fifty feet broad. In the center is a low mound fifteen feet in diameter. The opposite end of the egg extends into the distended jaws of the serpent. The serpent's head is seventy feet long and the neck seventy-five feet, and the entire length eleven hundred and sixteen feet. The serpent conforms itself to the shape of the hill, its body winding back, forming seven graceful curves, and terminating on the main land in a triple coil. The middle of the serpent is about fifteen feet lower than the head, and about twenty longer than the tail coil. On either side of the jaws extend two triangular elevations, as though intended for wings. Both the egg and the serpent's head are hollow. The structure contains more or less stone which has been revealed by the plow. The whole figure represents a serpent uncoiling itself on the mainland, and gliding towards a frog sitting upon the point of the spur, and just as it is in the act of seizing it, the frog leaps, ejecting an egg into the serpent's mouth. Shall we infer that here is a representation of phallic worship — the frog

representing the creative, the egg the productive, and the serpent the destructive powers of nature?"

HISTORY OF THE ACQUISITION OF SERPENT MOUND BY THE OHIO STATE ARCHÆOLOGICAL AND HISTORICAL SOCIETY.

The Serpent Mound was first prominently brought before the notice of the public by Messrs. Squier and Davis, who "discovered" the serpent during their archaeological explorations of the remains of the Mound Builders in the Ohio and Mississippi Valleys. This was about the year 1846. They found the mound in a very neglected condition, the young growth of forest and underbrush nearly obscuring the form and structure of the mound. They made a clearing sufficient to make some sort of a survey, which, however, has since proven to be incomplete and inaccurate. They published in their report to the United States Government, printed in 1848, a description of the mound, with a plate which is reproduced in this pamphlet. The description is also reprinted in these pages. Thirteen or fourteen years after the visit of Squier and Davis, a windstorm swept over the serpent hill, tearing up the trees and doing much damage to the serpent. This was followed by a clearing

of the land and the serpent was more or less muti-
lated by the cultivators of the soil. Subsequently na-
ture, through the regrowth of trees and settling of sod,
endeavored to repair some of the damage.

Prof. Frederick W. Putnam, Chief of the Eth-
nological and Archaeological Department of the Pea-
body Museum, Cambridge, Mass., became much inter-
ested in this mound, and in 1883, in company with
four fellow-archaeologists visited the mound, finding
it in a very neglected and deplorable condition. He
appreciated its value, realized that it was the greatest
specimen of its kind in the United States and per-
haps in the world. The mound upon which it is situ-
ated was then the property of Mr. Lovett. Prof. Put-
nam returned to Boston with the enthusiastic purpose
of securing funds for the purchase and restoration of
the serpent. He brought it to the attention of people
whom he thought would be interested in his purpose.
In 1885 he again visited the serpent, finding its de-
struction would be inevitable unless immediate
measures were taken for its preservation. He secured
a contract with the land-owner, that it should not be
further disturbed for at least one year; also getting
an option upon some 65 or 70 acres including and
surrounding the Serpent Mound. Again returning
to Boston, he secured the interest of Miss Alice C.

Fletcher, a wealthy lady interested in archaeology.
Miss Fletcher, through her efforts and those of Prof.
Putnam, assisted also by Mr. Francis Parkman, the
distinguished American historian, and Mr. Martin
Brimmer of the Corporation of Harvard University,
gathered a fund of nearly $6000, with which Prof.
Putnam purchased the property, the title being placed
in the name of the Trustees of the Peabody Museum,
Cambridge. These trustees were Prof. Asa Gray, Dr.
Henry Wheatland, Hon. Theodore Lyman, Hon. Geo.
F. Hoar, Francis C. Lowell and Prof. F. W. Putnam.
Following this purchase, in 1886, Prof. Putnam with
a corps of assistants spent portions of the three suc-
cessive summers in exploring the surroundings of the
mound, excavating various portions of it and the
mounds, village and cemetery sites in its immediate
vicinity, and in laying out the grounds thereabouts
so as to form what would be a park or resort grounds
for visitors and students. This was done at an ex-
pense of several thousand dollars in addition to the
cost of the purchase, the additional funds being also
raised through the agency of Prof. Putnam. Prof.
Putnam also, through the assistance of Mr. M. C.
Reed of Hudson, secured the passage of an act by the
legislature of Ohio to exempt the property from tax-
ation and put it under the special protection of the

laws of the state. This was the first law passed by
any legislative body for the protection of archaeologic
remains in the United States. Many have since been
passed by other states and by congress. The proper-
ty was placed under the protection of one of the neigh-
boring farmers who acted as warden for it. Thus
matters stood for four or five years, during which time
the Serpent Mound and park received slight care and
protection, owing to the fact that the proprietor, the
Peabody Museum, was so far distant that its officers
could not give it the proper attention. In the Spring
of 1894 the Secretary of the Ohio State Archaeolog-
ical and Historical Society (Mr. Randall) brought the
condition of the park to the attention of Prof. Putnam
and suggested the idea that its proper owner and pro-
tector should be the Ohio society. This matter finally
met with the approval of Prof. Putnam, who, during
his visit to Columbus at the convention of the Ameri-
can Association for the Advancement of Science
(August, 1899), stated to Prof. W. C. Mills, curator
of the Ohio society that if the society would accept,
repair and suitably preserve and care for the property,
he would advise the Trustees of the Peabody Museum
to transfer the property as proposed. In 1900 the
Secretary of the Ohio State Archaeological and His-
torical Society presented the matter to the Joint

Finance Committee of the Seventy-fourth General Assembly. That committee recommended to the legislature an appropriation for the repair and care of Serpent Mound, which appropriation was subsequently made. In the meantime, the Trustees of the Peabody Museum had transferred the title of the Serpent Mound and Park to the President and Fellows of the Harvard College. In accordance with the action of the legislature, Prof. Putnam brought the matter before the officers of Harvard College, who, after due consideration, voted to transfer the property to the Ohio State Archaeological and Historical Society. This transfer was perfected and the deed was acknowledged on the 8th day of October, 1900. The deed recites: "That this conveyance is upon the condition that the grantee corporation shall provide for the perpetual care of the Serpent Mound, and upon the further condition that the grantee corporation shall keep the Serpent Mound Park as a free public park forever, and the non-fulfillment or breach of said condition or either of them, shall work as a forfeiture of the estate hereby conveyed and revest the same in the grantor and its successors. And upon the further conditions that the grantee Society shall place and maintain in the park a suitable monument or tablet upon which shall be inscribed the record of the preser-

vation of the Serpent Mound and the transfer of the property to the State Society."

The Ohio society, the State of Ohio, and indeed all students of archaeology throughout the world are therefore mainly indebted to the enthusiastic, scholarly and indefatigible efforts of Prof. F. W. Putnam. Without his persistent and self-sacrificing work in this matter, Serpent Mound would probably have passed out of existence.

The Ohio society has thus far more than faithfully carried out the conditions of the transfer of this property. They have completely restored the park and serpent, have built a comfortable house upon the grounds near the serpent for the residence of the Superintendent of the grounds, Mr. Daniel Wallace, a most competent and faithful official. The society also erected upon the mound, just south of the serpent, a beautiful marble monument commemorative of the discovery of the mound by Squier and Davis, its subsequent restoration by Prof. Putnam and its transfer by Harvard University to the Ohio State Archaeological and Historical Society. Concerning the erection of this monument, Secretary Randall wrote in the editorial department of the society's quarterly for April, 1902, as follows:

On January 9, last, 1902, the Secretary of the

Ohio State Archaeological and Historical Society journeyed to the Mound, and was present to witness the erection of the tablet in the Mound Park, placed in accordance with the provisions of the deed transferring the Mound to the Society. The site selected for the monument was the summit of the circular prehistoric mound which is located on the highest elevation of the park, and is about 300 feet south of the coiled tail of the great serpent. The mound is some ten feet high, conical in shape. The monument consists of a granite base some five feet by two. The tablet, like the base, is of the best quality of Barre Granite, a handsome grey granite from Vermont. The tablet is about six feet high, two feet thick, and four feet broad. The lettered side is polished like a marble surface, and the inscription which is neatly cut into the surface in large Roman letters, reads as follows:

THE SERPENT MOUND PARK.

The Serpent Mound was first described by Squier and Davis in "Ancient Monuments of the Mississippi Valley," 1848,

Saved from destruction in 1885 by
FREDERICK WARD PUTNAM
Professor of American Archæology and Ethnology, Harvard **University.**

The Land included in the Park was secured
by subscription obtained by ladies of Boston in 1887, when it was
deeded to the Trustees of
The Peabody Museum, of Harvard University, Cambridge,
Massachusetts.

Exempted from taxation by Act of Legislature of Ohio in 1888.
Transferred by Harvard University, May 1900, to
Ohio State Archæological and Historical
Society for perpetual care as a
Free Public Park.

———

It was a clear but bleak midwinter day, and
standing upon the lofty plateau we could see across
the valley for miles to the hazy hills of Highland
County, one of the most picturesque scenes in South-
ern Ohio. There were no formal ceremonies. The
workmen tugged at the great granite slab while Mr.
Daniel Wallace, the custodian of the park, and the
Secretary of the Society the writer herewith, "stood
around" and gazed at the landscape or the curious
coils of the great earthen snake, the most mysterious
and interesting relic of the Mound Builders either in
the Ohio or the Mississippi Valley. Occasionally
some visiting stranger or passing traveler would
drive into the Park, look attentively at the weird and
inexplicable serpentine structure with all the awe and

amazement with which one could contemplate the Sphinx of Sahara, ask a few questions that nothing short of inspiration could answer, and then like the Arab with folded tent, silently "move off."

It was some seventeen years ago that Prof. F. W. Putnam of Harvard, visited the mound for the first time; observing the ravages age and neglect were making with this most valuable archaeological relic, he returned to Boston and wrote a letter to the Boston Herald, which was widely copied by the press, setting forth the value and condition of the serpent. Miss Alice Fletcher, a well-known Indian enthusiast, brought the matter before leading ladies of Boston at a lunch party given in Newport. The result was the issuing of a little circular, the assistance of Mr. Francis Parkman, the great historian, and Mr. Martin Brimmer, the raising of some six thousand dollars and the purchase and presentation of the mound to, and its placement in the hands of the Trustees of the Peabody Museum of American Archaeology and Ethnology. Some eight thousand dollars in all were expended upon the purchase and repair of this mound before it passed into the hands of the Ohio State Archaeological and Historical Society, through the suggestion and influence of Prof. F. W. Putnam. Surely not only Ohio and the Historical Society,

but the students of Archaeology and Ethnology throughout the country are to be congratulated that the great and unique remains of a bygone race are to be carefully preserved to students of the present and future. Hundreds of visitors resort to it each year, not alone from neighboring localities, but from all over the country, and indeed from countries beyond the seas. Scholars and curiosity seekers from the dominion of the "Old World" make pilgrimage to this wonderful structure, that was probably erected generations, perhaps centuries, before Columbus discovered the Western Continent.

SERPENT MOUNDS IN CANADA.

What is claimed to be a fine specimen of a serpent mound exists upon the brow of an elevation located on Mizang's Point, near the mouth of the Indian River, on the north shore of Rice Lake, about ten miles southeast of Peterboro, in the Province of Ontario and not far from the city of Toronto. The mound is named the Otonabee Serpent Mound because it is located in the township of Otonabee. Prof. David Boyle, the Curator of the Ontario Archaeological Museum, Department of Education, Toronto, Canada, in one of his annual reports describes this mound: "The situation is one of the most command-

ing on the shore, the land rising with a sharp acclivity
to a height of not less than seventy or eighty feet
from the water. On the very crest of this point lies
an embankment nearly two hundred feet in length,
in a generally easterly and westerly direction, one end
pointing a few degrees north of east and in line with
an oval mound twenty-three feet distant, the longer
axis of which measures fifty feet and the shorter axis
thirty-seven feet."

OTONABEE SERPENT MOUND, CANADA.

The serpent mound itself is one hundred and
eighty-nine feet in length, with an average breadth at
the base of twenty-four feet and an average height of
five feet. The breadth of the head is thirty feet nine
inches, the height four feet six inches. The accom-
panying cut, taken from the report of Prof. Boyle,
will give a clearer idea of the proportions and shape
of the serpent than any lengthy description. Prof.
Boyle, with other archaeologists, laid bare a section
of the oval mound and found eight feet from the north
edge and two feet below the surface, two human

skeletons in a sitting position, and about the same
distance from the south side were a skull and some
of the larger bones of the arms and legs — these were
also within two feet of the surface, but somewhat
more than twelve inches higher, measuring from the
general level. In another part of the mound were
found a human skull, some dog or wolf teeth, the jaw
of a small quadruped, small pieces of mussell shells
and charcoal, and also a human skeleton lying on its
right side. Prof. Boyle then concludes: "While
there was no doubt that the remains found in the first
cut were those of intrusive or comparatively recent
burial, it seems quite clear that the bones here found
on the base level had been so placed before the con-
struction of the mound, and it appears probable that
the same holds good in relation to the isolated skull
found only a little more than a few feet away."

These discoveries in the oval mound determined
in the mind of Prof. Boyle the fact that both the oval
and the serpentine structure were artificial mounds,
the work of human hands and evidently intended to
represent the oft-repeated combination of the egg and
the snake.

Says Prof. Boyle: "On the identification of this
earthwork as a serpent mound, it will be readily
understood that more than ordinary interest became

connected with every one of its details. Unlike the Scottish one on Loch Nell, in Argyleshire, and the Adams County one in Ohio, the head of the Otonabee serpent points in an easterly direction. It differs from both also in the number of its convolutions which exceed those of the Scottish mound, and are less than those of the Ohio one, the former having only two, giving the work an S-like look, and the latter (Ohio) having seven. The position of the oval mound, too, at once suggested the ancient combination of the serpent and the egg, and here we are tempted to institute a comparison with the Adams County example, quite to the advantage of the Otonabee structures, for while the oval on the head of the former (Ohio) consists of an embankment enclosing a basin, the Otonabee is a solid structure throughout. Mr. Boyle made an incision into the body of the serpent itself some seventy feet from the end of the tail. We give the result of his own words: "I had a cut made five feet wide, extending from the north side to the middle of the bank, which is here twenty-four feet across the mase, simply to examine the interior nature of the structure, the surface of which was here somewhat stony, a fact that no doubt counts for its hitherto non-disturbance by white savages, some of whom are said to have searched (very stupidly) for hidden

treasure, and not for bones. Human bones were ex-
posed within two feet of the surface, but like those
of the egg mound, all much decayed. Some of the
bolders taken from this cut were all that a man could
lift, but many of them did not weigh more than from
ten to twenty or thirty pounds each. The placing of
the earth was manifestly done by hand, layers and
patches of dark soil being mingled with yellow clay;
beyond this there was nothing to indicate man's
agency, but the proof yielded was ample. A slight
examination was made at the head of the mound, the
result being that to show here also comparatively
recent burials had been made, but lower than eighteen
inches from the surface there was no sign of bones."

Prof. Boyle decides this serpent was a rattle-
snake and that it was made by the Indians. "With re-
gard to serpents, (drawings, incisings, or effigies of
which are found at wide intervals over the greater
part of North America), it has been observed that in
nearly every instance the model was a rattlesnake.
Both, or either, of the extremities may aid in this
identification. Unfortunately the outline of the
Otonabee Serpent's head is not sufficiently sharp to
assist us, but the great length of the tail portion (all
behind the last bend), was intended, we may suppose,
to include a rattle. Indeed, there is a very slight

bend about midway in this portion, which may have meant to mark the feature in question. Imagination may run riot in attempting to account for the origin and purpose of such earthworks. With regard to the Otonabee Serpent and Egg only two things are certain, namely, that the embankments are of human workmanship, and that they were made by a people — Indians of course — prior to the arrival here of the Huron-Iroquois. Of what stock these people were we have no knowledge. A lingering fondness for such structures among some tribes of Ojibwa origin, until very recently, regarded as an evidence of heredity, might warrant us in attributing to some old-time Algonkins the making of these mounds. However this may be, our chief source of wonder is connected with the ideas that were entertained by the Mound Builders in fashioning such serpent-and-egg embankments. It has been well observed respecting the similarities existing among primitive folk everywhere in the shaping of their weapons, and the tenor of their myths, that, given corresponding environments, human nature being the same all over the world, is bound to manifest itself along certain fixed lines. In a general way it is easy to concede this proposition, but in a case like the one before us there is a difficulty. We may fully admit the probabilities favoring the re-

spect paid by early man to the serpent on the one hand, and to the egg on the other, in connection with the great mystery of life, the latter symbolizing its origin, and the former, on account of its periodical skin-shedding, being suggestive of rejuvenescence and perpetuity — hence of eternity, but it is not so easy to account for the coupling of these symbols, by peoples widely separated in point of time, as well as of distance."

THE SERPENT OF LOCH NELL.

We have stated that the Great Serpent in Adams County is the largest and best preserved effigy relic of the Mound Builders, certainly in the United States and probably in the whole world. It has, however, a counterpart in the Old World. In Great Britain, as is well known, there are frequent remains of a race of people similar to, if not identical with, the Mound Builders of America. Their European relics, however, are mostly of stone, seldom purely of earth. In Scotland there is a very remarkable and distinct serpent, constructed of stone. This work has so much in common with the Ohio serpent that we produce the description of it as given by Miss Gordon Cummin in "Good Words" for March, 1872. We also reproduce a cut of the Serpent of Loch Nell, showing its great resemblance to the Ohio Serpent.

"The mound is situated upon a grassy plain. The tail of the serpent rests near the shore of Loch Nell, and the mound gradually rises seventeen to twenty feet in height and is continued for three hundred feet, "forming a double curve like the letter 'S,' and wonderfully perfect in anatomical outline. This we perceive the more perfect on reaching the head, which lies at the western end. . . . The head forms a circular cairn, on which, at the time of Mr. Phené's first (1871) visit (several years previous), there still remained some trace of an altar, which has since wholly disappeared, thanks to the cattle and herd boys." Mr. Phené excavated the circular cairn, or circle of stones, forming the head, and although it had been previously disturbed, he found "three large stones forming a megalithic chamber, which contained burnt bones, charcoal, and burnt hazel-nuts," and an implement of flint was also found during the excavation. "On removing the peat-moss and heather from the ridge of the serpent's back, it was found that the whole length of the spine was carefully constructed, with regularly and symmetrically placed stones, at such angles as to throw off the rain. The spine is, in fact, a long narrow causeway made of large stones, set like the vertebrae of some huge animal. They form a ridge, sloping off at each side,

which is continued downward with an arrangement of smaller stones suggestive of ribs. The mound has been formed in such a position that the worshipers, standing at the altar, would naturally look eastward, directly along the whole length of the great reptile, and across the dark lake to the triple peaks of Ben Cruachan. This position must have been carefully selected, as from no other point are the three peaks visible."

General Forlong, in commenting on this, says:

'Here, then, we have an earth-formed snake, emerging in the usual manner from dark water, at the base, as it were, of a triple cone, — Scotland's Mount Hermon, — just as we so frequently meet snakes and their shrines in the East.'

"Is there not something more than mere coincidence in the resemblance between the Loch Nell and the Ohio serpent, to say nothing of the topography of their respective situations? Each has the head pointing west, and each terminates with a circular enclosure, containing an altar, from which looking along the most prominent portion of the serpent, the rising sun may be seen. If the serpent of Scotland is the symbol of an ancient faith, surely that of Ohio is the same."

The following poem by **Prof.** Blackie accompanies the description of the Loch Nell Serpent by Miss Cummin:

Why lies this mighty serpent here,
 Let him who knoweth tell —
With its head to the land and its huge tail near
 The shore of the fair Loch Nell?

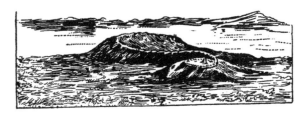

THE STONE SERPENT OF LOCH NELL.

Why lies it here? — not here alone,
 But far to East and West
The wonder-working snake is known,
 A mighty god confessed.

Where Ganga scoops his sacred bed,
 And rolls his blissful flood,
Above Trimurti's threefold head
 The serpent swells his hood.

And where the procreant might of Nile,
 Impregned the seedful rood,
Enshrined with cat and crocodile
 The holy serpent stood.

And when o'er Tiber's yellow foam
 The hot sirocca blew,
And smote the languid sons of Rome
 With fever's yellow hue,

Then forth from Esculapius' shrine
 The Pontiff's arm revealed,
In folded coils, the snake divine,
 And all the sick were healed.

And Wisest Greece the virtue knew
 Of the bright and scaly twine,
When winged snakes the chariot drew
 From Dame Dememter's shrine.

And Maenad maids, with festive sound,
 Did keep the night awake,
When with three feet they beat the ground,
 And hymned the Bacchic snake.

And west, far west, beyond the seas,
 Beyond Tezcuco's lake,

In lands where gold grows thick as peas,
 Was known this holy snake.

And here the mighty god was known
 In Europe's early morn,
In view of Cruachan's triple cone,
 Before John Bull was born.

And worship knew of Celtic ground,
 With trumpets, drums and bugles,
Before a trace in Lorn was found
 Of Campbells or Macdougalls.

And here the serpent lies in pride
 His hoary tale to tell,
And rears his mighty head beside
 The shore of fair Loch Nell.

Coachwhip Publications

COACHWHIP BOOKS.COM

Printed in the USA
CPSIA information can be obtained
at www.ICGtesting.com
LVHW041217191123
764363LV00004B/323

9 781616 461676